P9-APU-163

Rebekah L. Smith

Seasons of
WOOL APPLIQUÉ
Folk Art

CELEBRATE AMERICANA
with 12 Projects to Stitch

C&T PUBLISHING

Text copyright © 2017 by Rebekah L. Smith

Photography and artwork copyright © 2017 by C&T Publishing, Inc.

Publisher: Amy Marson

Creative Director: Gailen Runge

Editors: Liz Aneloski and Katie Van Amburg

Technical Editor: Ellen Pahl

Cover/Book Designer: April Mostek

Production Coordinator: Tim Manibusan

Production Editor: Jennifer Warren

Illustrator: Kirstie L. Pettersen

Photo Assistant: Mai Yong Vang

Hand Model: Kristi Visser

Style photography by Laura Webb and instructional photography by Diane Pedersen of C&T Publishing, Inc., unless otherwise noted

Published by C&T Publishing, Inc., P.O. Box 1456, Lafayette, CA 94549

All rights reserved. No part of this work covered by the copyright hereon may be used in any form or reproduced by any means—graphic, electronic, or mechanical, including photocopying, recording, taping, or information storage and retrieval systems—without written permission from the publisher. The copyrights on individual artworks are retained by the artists as noted in *Seasons of Wool Appliqué Folk Art*. These designs may be used to make items for personal use only and may not be used for the purpose of personal profit. Items created to benefit nonprofit groups, or that will be publicly displayed, must be conspicuously labeled with the following credit: "Designs copyright © 2017 by Rebekah L. Smith from the book *Seasons of Wool Appliqué Folk Art* from C&T Publishing, Inc." Permission for all other purposes must be requested in writing from C&T Publishing, Inc.

Attention Copy Shops: Please note the following exception—publisher and author give permission to photocopy pages 12, 13, 19–21, 32, 33, and 83 and pattern pullout pages P1–P4 for personal use only.

Attention Teachers: C&T Publishing, Inc., encourages you to use this book as a text for teaching. Contact us at 800-284-1114 or ctpub.com for lesson plans and information about the C&T Creative Troupe.

We take great care to ensure that the information included in our products is accurate and presented in good faith, but no warranty is provided nor are results guaranteed. Having no control over the choices of materials or procedures used, neither the author nor C&T Publishing, Inc., shall have any liability to any person or entity with respect to any loss or damage caused directly or indirectly by the information contained in this book. For your convenience, we post an up-to-date listing of corrections on our website (ctpub.com). If a correction is not already noted, please contact our customer service department at ctinfo@ctpub.com or at P.O. Box 1456, Lafayette, CA 94549.

Trademark (™) and registered trademark (®) names are used throughout this book. Rather than use the symbols with every occurrence of a trademark or registered trademark name, we are using the names only in the editorial fashion and to the benefit of the owner, with no intention of infringement.

Library of Congress Cataloging-in-Publication Data

Names: Smith, Rebekah L. (Rebekah Leigh), 1971- author.

Title: Seasons of wool appliqué folk art : celebrate Americana with 12 projects to stitch / Rebekah L. Smith.

Description: Lafayette, CA : C&T Publishing, Inc., 2017.

Identifiers: LCCN 2016049583 | ISBN 9781617454806 (soft cover)

Subjects: LCSH: Appliqué--Patterns. | Folk art--United States. | Americana.

Classification: LCC TT779 .S632 2017 | DDC 746.44/5--dc23

LC record available at https://lccn.loc.gov/2016049583

Printed in China

10 9 8 7 6 5 4 3 2 1

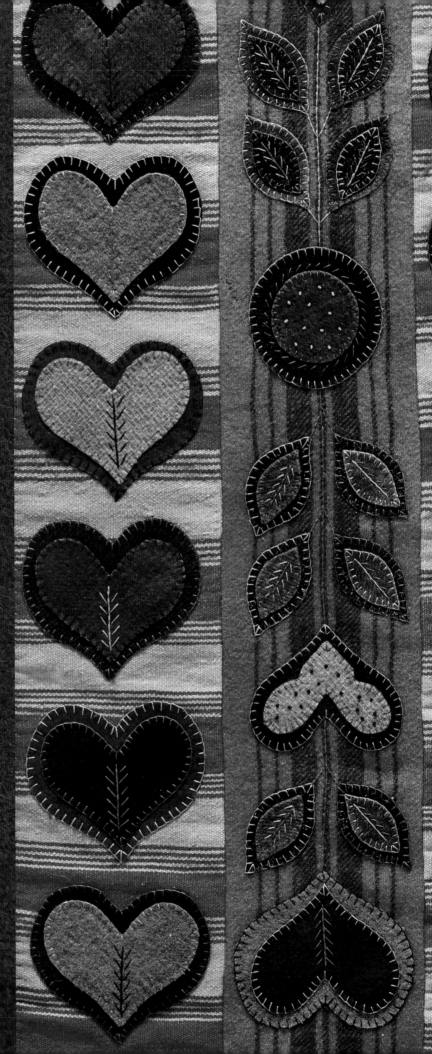

DEDICATION

To my parents, Charles and Christine Miller, who led me to a deep, abiding faith in the Lord and introduced me to the treasures of our American ancestors.

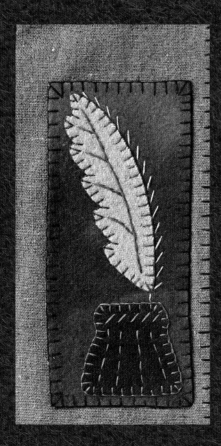

ACKNOWLEDGMENTS

A book such as this really is a group effort to produce. There are so many involved in the process, both on my end and at C&T Publishing. I would like to mention those who have added so much to this publication.

The Lord has set my path, for which I am grateful. My husband, Bruce, is my constant support and partner in all of this. Our daughters, Kelsey, Karly, and Tessa, are a big part of everything I do, and I couldn't keep it up without them. My dear friend Andrea spends precious time with me in the studio, making good use of scissors.

Thank you doesn't even begin to cover how grateful I am to all of my friends who have given much encouragement just when I needed it. To everyone who enjoyed the first book and asked for a second, it really meant a lot, and I appreciate hearing from so many of you either in class, by email, or in passing. Thank you!

Once again, Laura Webb took the beautiful staged photos for each project. She has an amazing eye both in front and behind the camera. She really captures each piece.

Every part of this book has been carefully compiled by a talented group at C&T Publishing. Roxane Cerda was a great acquisitions editor and always had great ideas. Liz Aneloski, my developmental editor, had the job of getting all of the different parts of this book from me and making sure all was complete. Ellen Pahl acted as my technical editor again and was so patient with me. She really has a way of discerning what I am trying to convey in the instructions and making things very clear.

Jennifer Warren, the production editor, wrapped up all of the important parts of the book. I really appreciate her diligence and organizational skills. As the production coordinator, Tim Manibusan had the important job of pulling the manuscript together, making sure the photos and illustrations were correct, and reviewing the design and layout.

A very integral part of this book of projects were the flat shots of the finished pieces—Diane Pedersen was the photographer for these shots, along with her assistant, Mai Yong Vang. Thank you, ladies, for a fantastic job!

Kirstie L. Pettersen created all of the beautiful illustrations; I appreciate her attention to the details. Finally, April Mostek did an amazing job with the design of the book. She is so nice to work with, and she really understands the "look" of my work.

They were a great team, and I am so grateful for all of the hard work they put into this book.

CONTENTS

Introduction 6

PROJECTS

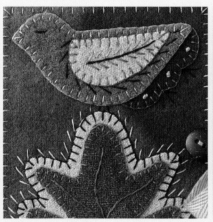
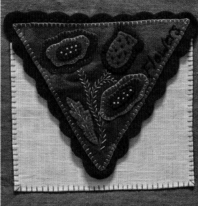
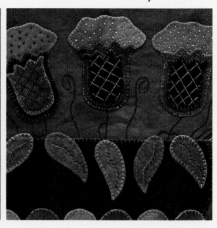

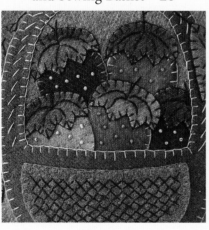

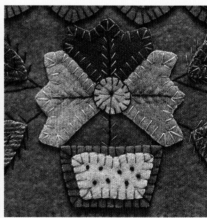

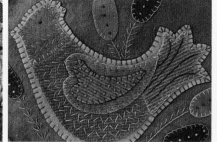

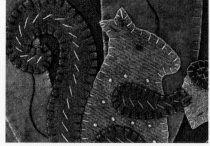
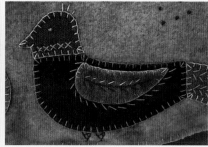
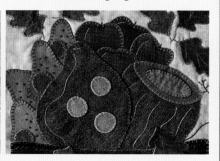

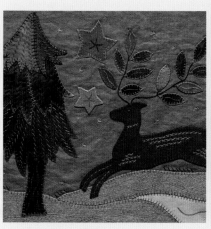
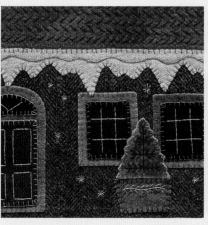
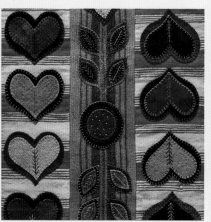

INTRODUCTION

*E*ach season of the year holds its own special delight for me. Inspiration comes from all of the sounds, smells, colors, and light that the seasons allow us to enjoy. The turning of the seasons can enable us to cultivate our own creativity and share with others how we see the beauty that surrounds us. In this book I wanted to branch out and fill the pages with projects that are not only lovely to look at but have a unique functionality for different times of the year. The projects have their own seasonal qualities and have been a large part of my life as the writing and stitching have come together. As you take the time to browse through these pages, know that I appreciate how precious time is and am thrilled that you chose to spend it here.

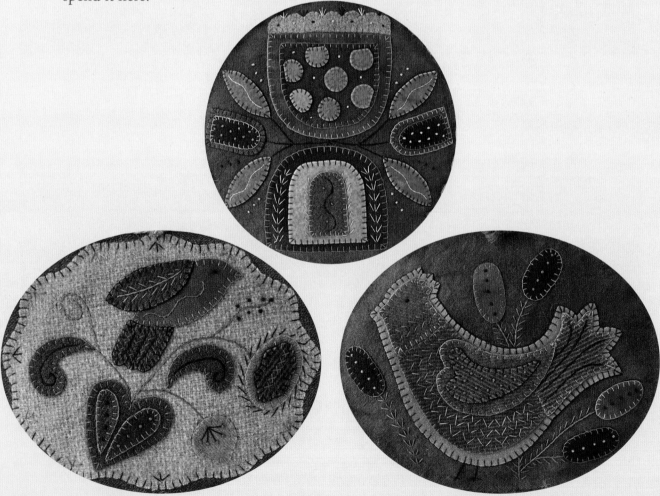

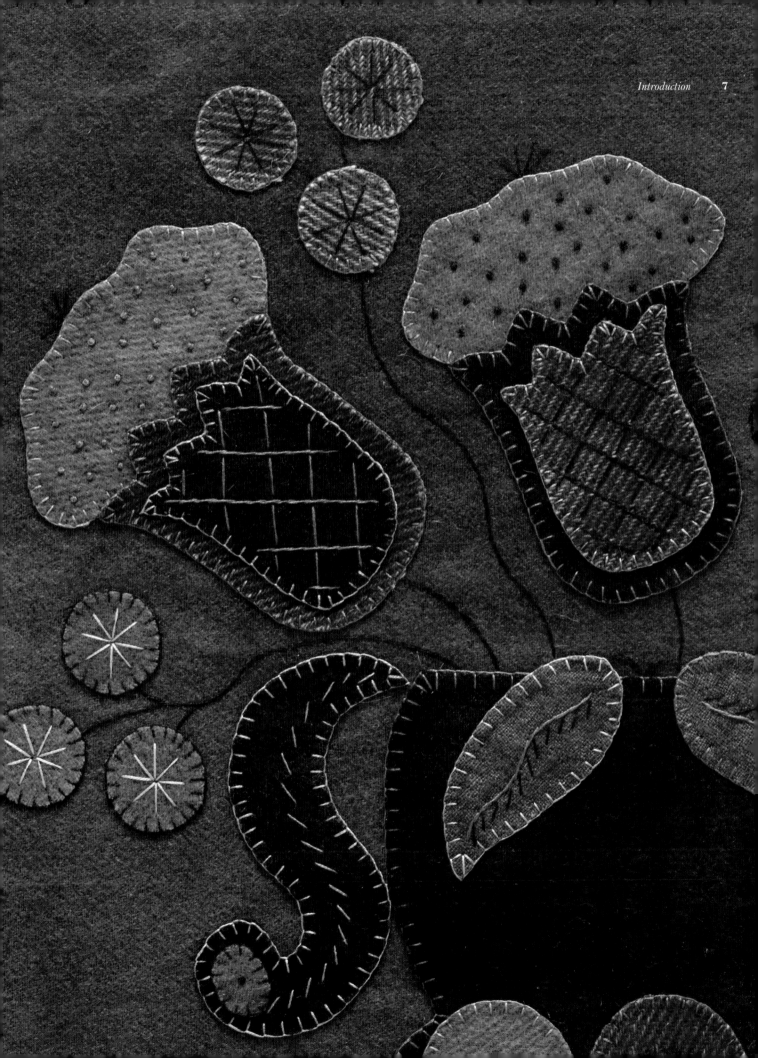

MARCH MUSINGS

Finished journal cover: 5¼″ × 8″ closed • 10½″ × 8″ open

As spring approaches in my neck of the woods, I start to feel the pull to look through seed catalogs and spring fabric swatches and find out what the latest fashions for warmer weather will be. The main ideas that begin to sprout, though, are the new designs and pieces I will work on in the coming year. My winter work is almost behind me, and I want to start on new projects and allow them to grow and thrive.

My first approach to developing new designs is to keep lots of notes and sketches. It's important to always have something to write on, as inspiration can come from anywhere at any time. This cover for a journal or sketchbook is a great way to keep track of ideas, because they can go as easily as they come. Be sure to tuck in color swatches and other bits and pieces that motivate your creativity as well.

Keeping a sketchbook and pencils at hand is a must, as inspiration comes from many places.

Photo by Karly A. Smith

The lovely appearance of your functional objects can be an inspiration in itself. I find I am attracted to and more likely to use a tool if it has its own beauty—and a journal or sketchbook is one of my most important tools.

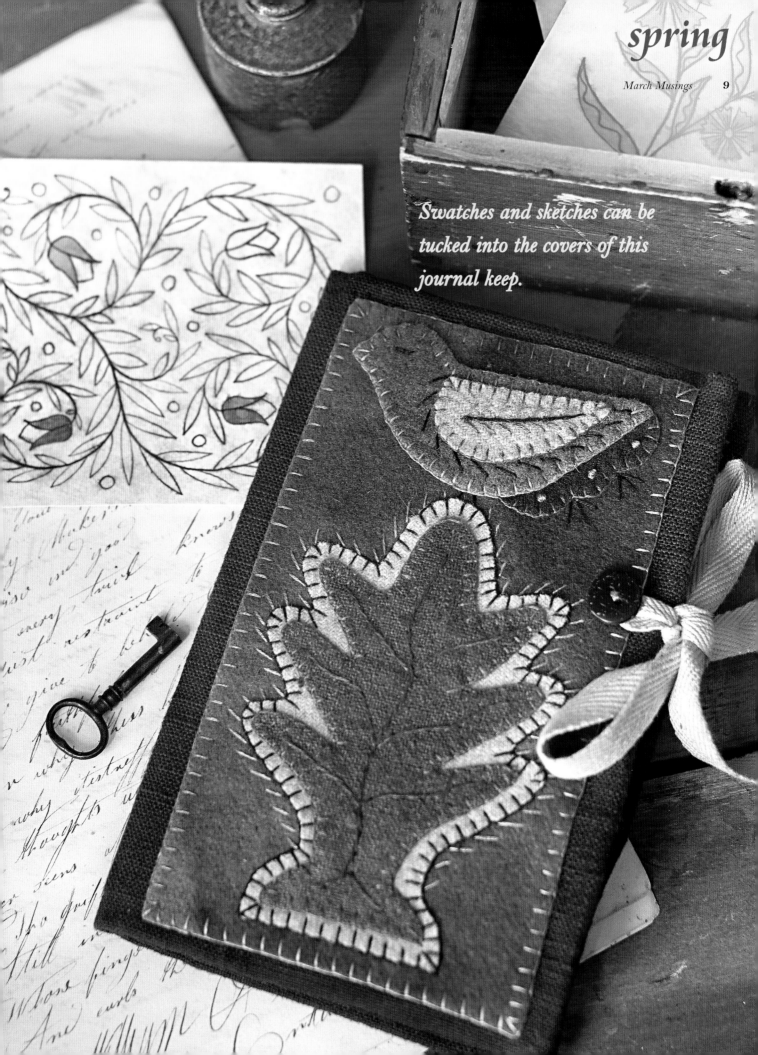

Swatches and sketches can be tucked into the covers of this journal keep.

MATERIALS

Fabrics

note This cover fits a 5″ × 7″ journal.

- 1 piece of brown linen or heavy cotton 9¼″ × 11¾″ for cover

- 2 pieces of light blue linen or cotton 4½″ × 7¾″ for flaps

- 1 brown wool rectangle 8″ × 11″ for backgrounds of cover, pencil pocket, and square pocket

- 1 blue wool rectangle 4″ × 5″ for inside pocket and bird

- 1 tan wool square 6″ × 6″ for tree, bird wing, and feather

- 1 green wool rectangle 3″ × 5″ for tree

- 1 dark brown wool square 3″ × 3″ for inkwell and bird tail

Other materials

- Embroidery floss: 1 skein each of dark brown, antique white, and mustard

- 5″ × 7″ journal*

- 2 buttons, ⅝″ diameter

- ⅔ yard of beige ½″-wide cotton twill tape

- Pinking shears (*optional*)

*See Resources (page 95).

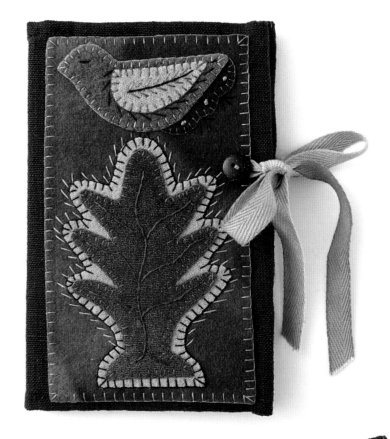

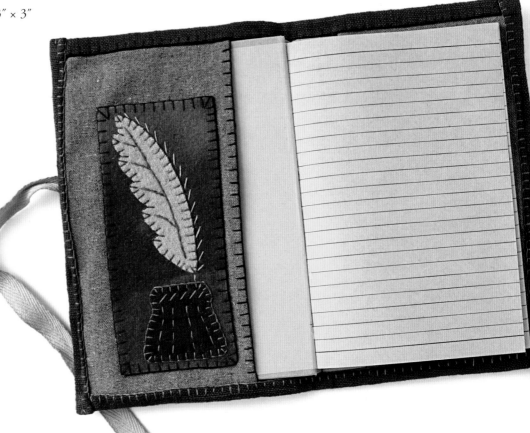

GETTING STARTED

Refer to Preparing the Wool Pieces (page 90) as needed for additional details on these steps.

1. Cut out the wool appliqué pieces using the patterns (pages 12 and 13). I cut the inner square for the back pocket with pinking shears, but if you don't have pinking shears you can use a small, sharp pair of scissors to cut it as desired.

2. Lay out the whole project to be sure you have all of the wool pieces.

SEWING FUN

Refer to Stitching Your Project (page 90) for details on the blanket stitch and embroidery stitches.

1. Using the blanket stitch, appliqué the front cover wooly and both pockets for the flaps.

2. Add the embellishment stitches.

3. Using a steam iron on the wool setting, press each finished piece on the wrong side.

4. Position and pin the finished piece for the front cover on the brown linen or cotton background, as shown, and appliqué it in place using a blanket stitch.

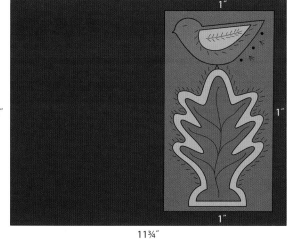

5. Fold the inner 7¾″ edge of each light blue linen rectangle under ¼″ twice and finish with a blanket stitch.

6. Position and pin the remaining wool pieces onto the light blue linen rectangles. Appliqué in place using a blanket stitch to make the flaps for the inside.

7. Place the flaps onto the wrong side of the brown background and pin in place, leaving ¾″ all around.

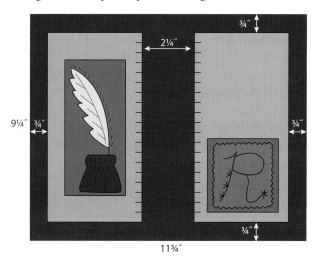

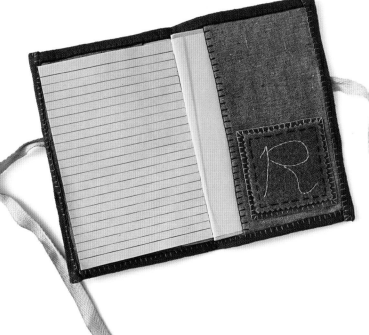

8. Fold the top and bottom outer edges of the brown background fabric over twice, covering the raw edges of the flaps, and pin. Blanket stitch across the top and bottom edges. Repeat with the side edges.

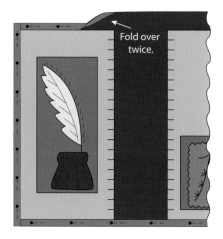

9. Insert the journal.

10. Cut the length of twill tape in half. Pin 1 piece to the front cover, centering it along the edge of the wool and folding the raw edge under so that it is concealed.

11. Add a couple of stitches to hold the twill tape in place, and then center the button over the stitches. Sew the button in place.

12. Pin and sew the second piece of twill tape to the back cover in the same manner.

Keep your journal close at hand!

March Musings

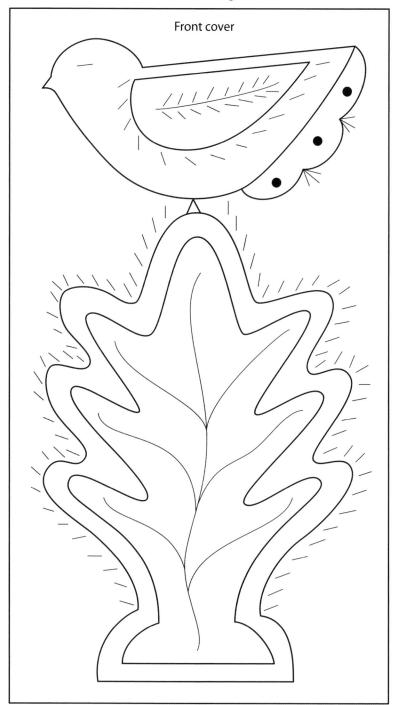

Front cover

March Musings

Pocket

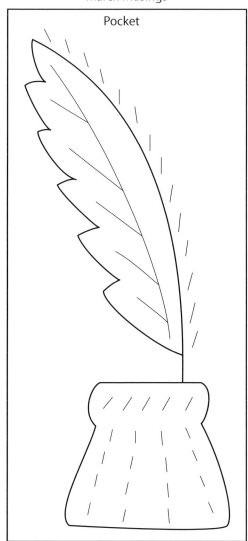

March Musings

Pocket

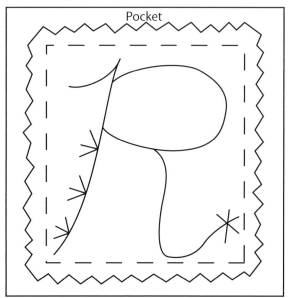

SEWING IN THE SEED TIME

Finished wallhanging: 10″ × 28″

Preparing for seed time

*E*ach year I look forward to getting my fingers in the dirt and planting those tiny seeds that grow into such wonderful plants. Gardening is one of those springtime jobs that I never have enough time for, so I cherish the moments when I can be outside in the fresh air, putting seeds in the ground and tending to the new shoots.

I needed a way to organize my collection of seed packets as well as keep them handy and ready for action when I could get to the garden for a few minutes. My former storage idea was to put them in a plastic bag in a cupboard. While this was effective, it was rather unattractive. So much of my work is inspired by the plants and flowers that come from these seeds, so I decided to design a piece that was functional for storage and also paid homage to the beauty stored in these tiny vessels.

This is a versatile project that can be used in different ways. The pockets look beautiful on the wall, and they are readily available for trips to the garden. The piece can also be rolled up and tied with the twill tape for easy storage or transportation. If you don't plant seeds, you could use this to hold keys by the door; stationery items, such as cards, envelopes, and stamps; or sewing notions, of course!

Whatever inspires you to make this project, I hope that it brings you joy in the making and using of it.

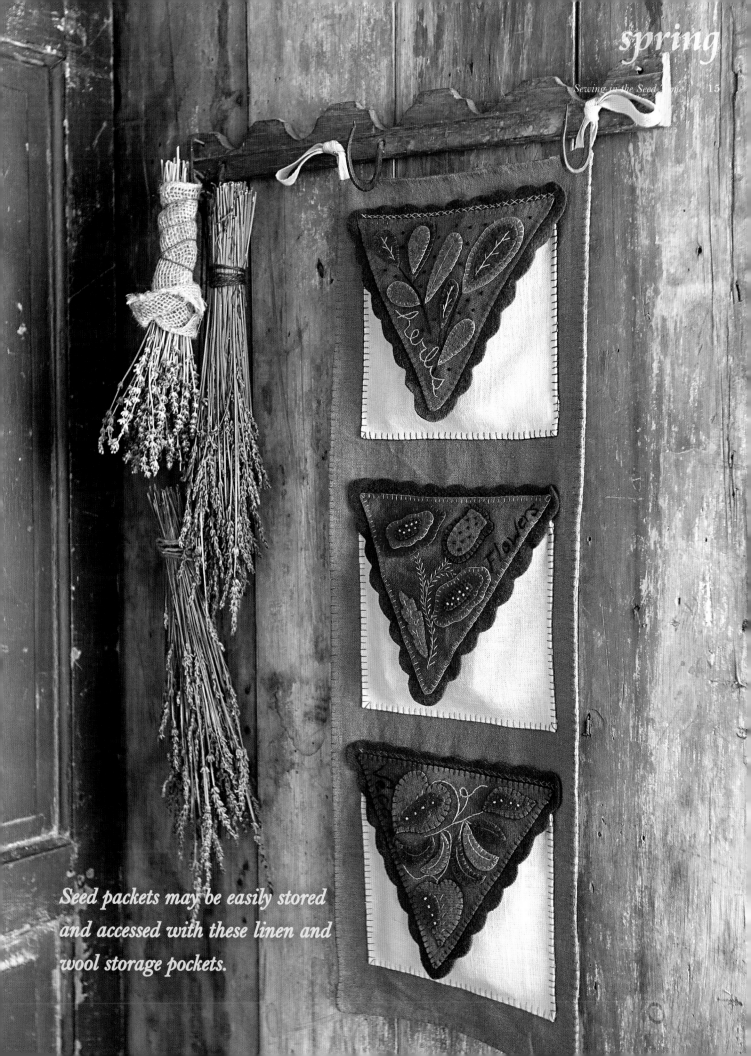

Seed packets may be easily stored and accessed with these linen and wool storage pockets.

MATERIALS

Fabrics

> **note** For this project, I used wools from Marcus Fabrics that I overdyed with coffee to give them an aged look.

- 2 taupe linen rectangles 10½″ × 28½″ for background

- 3 natural linen pieces 8″ × 8½″ for pockets

- 1 forest green wool rectangle 7″ × 20″ for background triangles and flower pod

- 1 dark green wool rectangle 8″ × 24″ for scalloped triangle pocket flaps and flower centers

- 1 murky green wool rectangle 5″ × 7″ for leaves and pods

- 1 green wool rectangle 5″ × 7″ for leaves and pods

- 1 cinnamon wool square 3″ × 3″ for flowers

- 1 pumpkin wool square 3″ × 3″ for flowers

Other materials

- Embroidery floss: 1 skein each of dark brown, antique white, and mustard

- 1 yard of beige ½″-wide cotton twill tape

---------------------- **Hint** ----------------------

To overdye wool with coffee, I use the cheapest instant coffee I can find. Simply heat up a pan of water (it's not necessary for it to boil) and dissolve some instant coffee in it. It does not take many coffee crystals to get the color to the desired effect. Add the wool and let it simmer for about fifteen minutes. Allow it to cool completely before taking the wool out of the coffee bath. Rinse the wool a bit and hang it to drip dry, then fluff it in the dryer. I suggest dyeing a batch of different scraps first to see what you get.

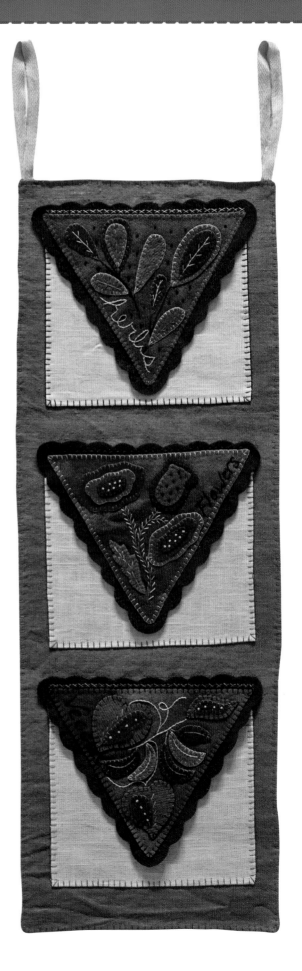

GETTING STARTED

Refer to Preparing the Wool Pieces (page 90) as needed for additional details on these steps.

1. Cut out the wool appliqué pieces using the patterns (pages 19–21).

2. Lay out the whole project to be sure you have all of the wool pieces.

SEWING FUN

Refer to Stitching Your Project (page 90) for details on the blanket stitch and embroidery stitches.

1. Using the blanket stitch, appliqué all of the wool pieces onto the 3 background triangles.

2. Add the embellishment stitches.

3. Using a steam iron on the wool setting, press each finished triangle on the wrong side.

4. Stitch the background triangles to the scalloped triangles for the pocket flaps.

5. Using the steam iron on the wool setting, press the finished wool pieces on the wrong side.

6. Cut the length of twill tape in half and fold each half in half again. Place the folded halves on the right side of a taupe linen background piece along a 10½″ side, with the loose tape ends aligned with the edge of the linen and the loops facing down. Place the raw edges about ⅜″ in from each side to allow for the seam and pin.

Note: You may want to trim the twill tape to shorter lengths. Decide where you will hang or display the finished piece to determine the best length for the hanging loops.

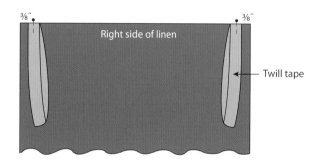

7. Layer the second taupe linen background piece on top of the first with right sides together and pin. Sew around 3 sides by machine, using a ¼″ seam allowance; leave the 10½″ end without the twill tape unsewn. This will be the bottom.

8. Turn right side out and press flat.

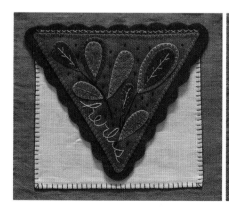
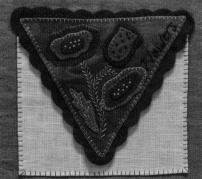
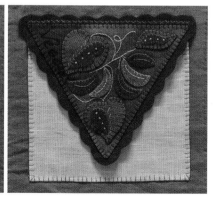

9. On each linen pocket rectangle, turn under and iron a ¼″ hem on all 4 sides. Turn under an 8½″ side by ¼″ again and press to create a finished hem for the top of the pocket opening.

10. Position the 3 pockets on the background linen, as shown, and pin them securely. The opening on the background linen should be at the bottom.

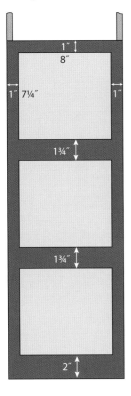

11. Using the blanket stitch, sew 3 sides of each linen pocket to the background linen. Blanket stitch the top edge of each pocket, keeping it open for inserting your seed packets.

----------------- *Hint* -----------------

Slide a piece of cardboard between the two layers of background linen to keep from stitching them together.

12. Pin a pocket flap to the background linen above each pocket. Using a simple cross-stitch, sew the pocket flaps to the background linen.

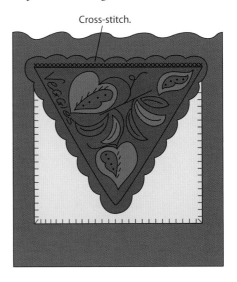

Cross-stitch.

13. Using the iron on the wool setting, press the whole piece on the wrong side.

14. Turn the bottom raw edges of the background linen under ¼″, press, and pin the opening closed.

15. Blanket stitch all the way around the linen background piece.

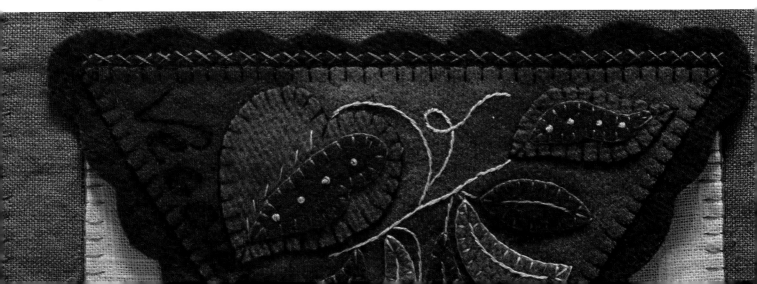

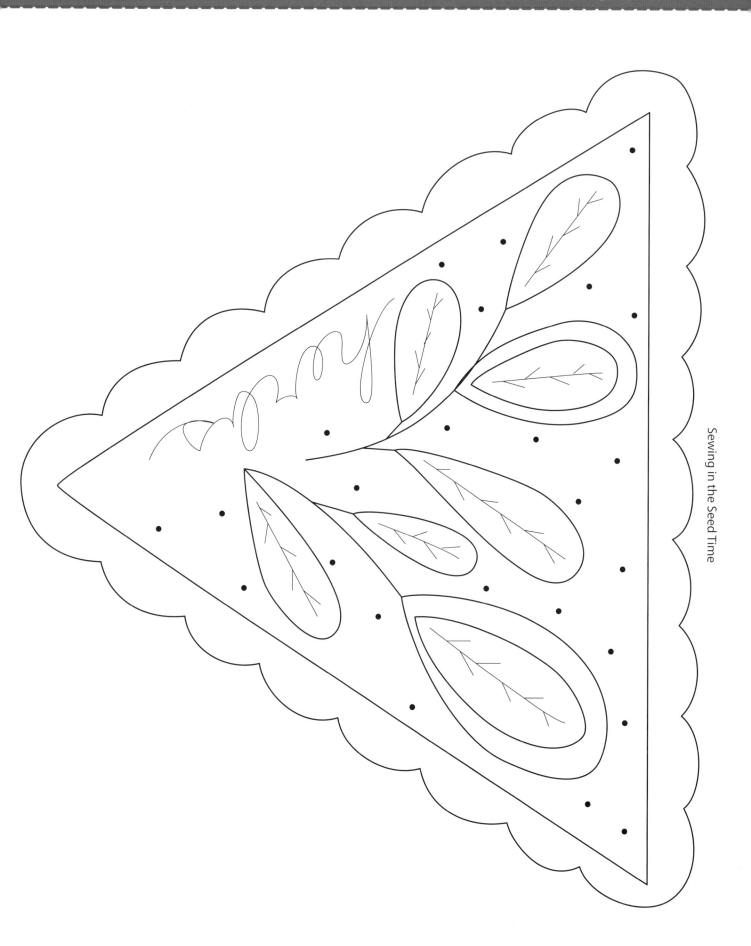

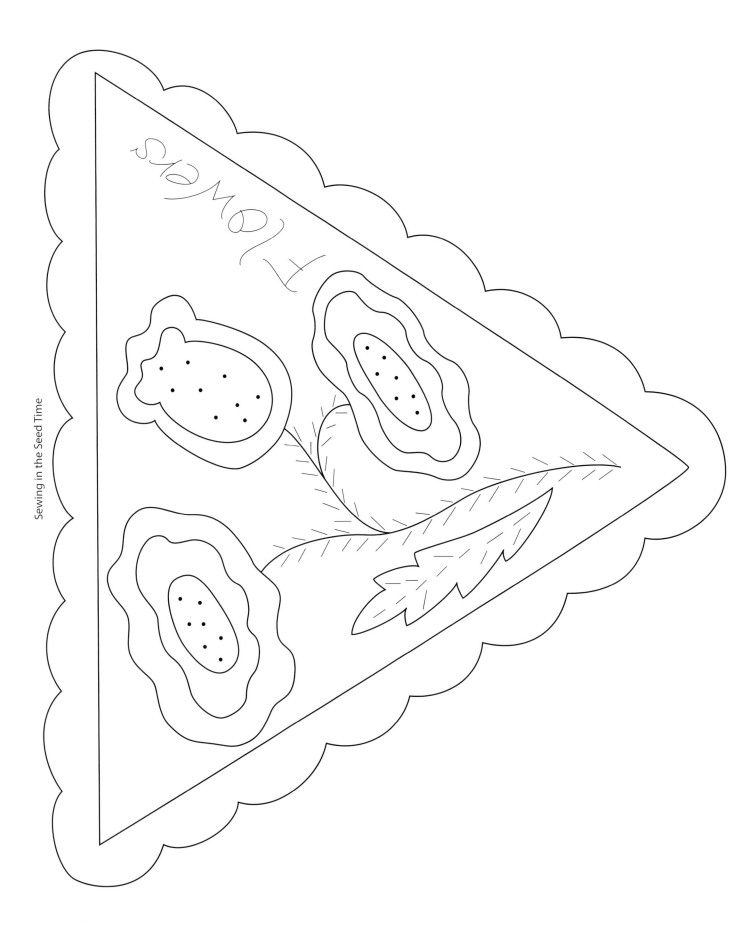

Sewing in the Seed Time

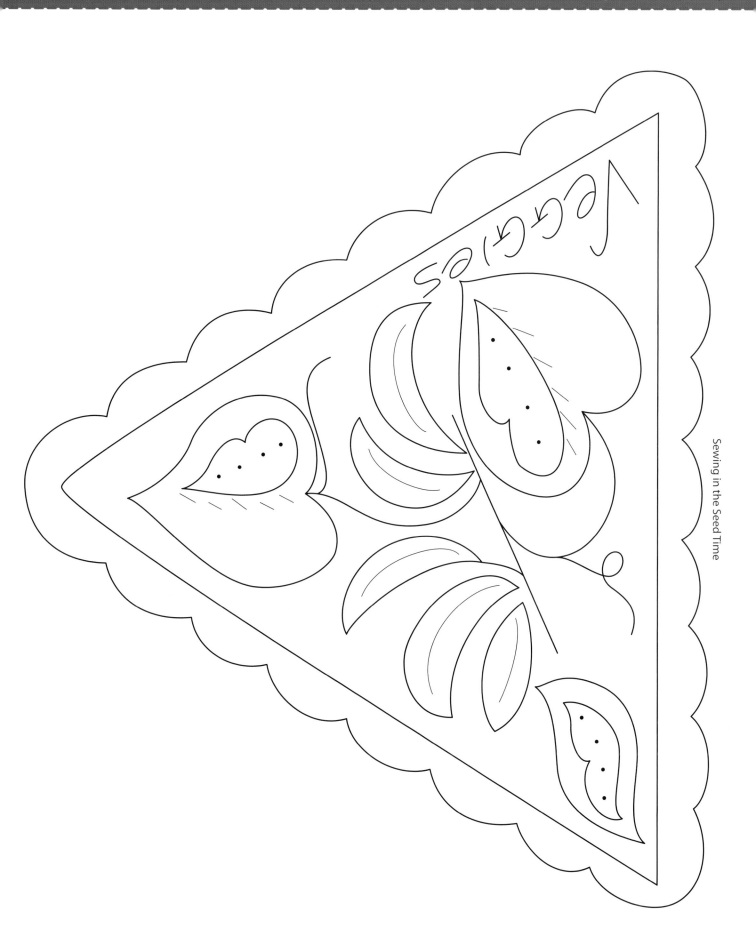

AT THE URN OF THE SEASON

Finished pillow-cover wooly: 15″ × 30″

*I*n spring we finally put away our winter blankets and wool coverlets. It's time to bring out the fresh spring bedding and brighten up our spaces with thoughts of longer days and the sweet scents of flowering branches. This project emulates the pots of flowers that begin to appear on porches and doorways as we welcome the spring rains and the warmer weather.

The tulip has long been one of my favorite motifs to use in painting and stitching. There are so many varieties and forms

Tulips are simple harbingers of spring.

Photo by Kelsey A. Smith

that can be interpreted for folk art. Filling a wooly urn planter with these delightful blossoms is the perfect way to bring them into your home's decor. I have attached mine to a bolster cover as a pleasing addition to our springtime bed linens.

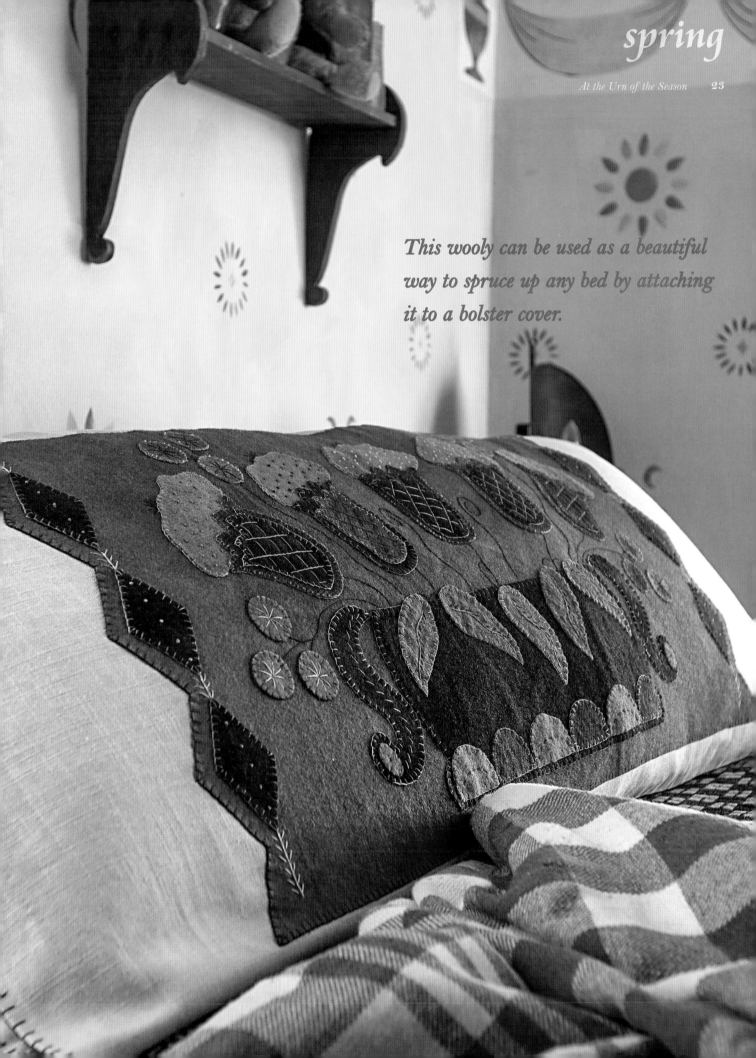

This wooly can be used as a beautiful way to spruce up any bed by attaching it to a bolster cover.

MATERIALS

Fabrics

- 1 brown wool rectangle 15″ × 30″ for background

- 1 black wool square 15″ × 15″ for urn, urn handles, tulips, and diamonds

- 1 red wool rectangle 7″ × 15″ for tulips, half-circles, and small circles

- 1 mustard wool rectangle 8″ × 10″ for tulip tops, half-circles, urn handle centers, and small circles

- 1 green wool rectangle 5″ × 8″ for leaves

Other materials

- Embroidery floss: 3 skeins each of dark brown, antique white, and mustard

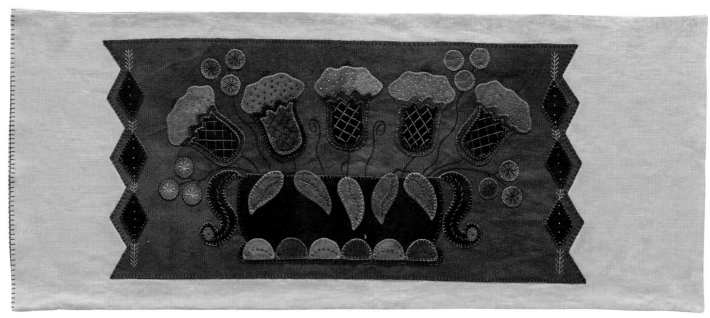

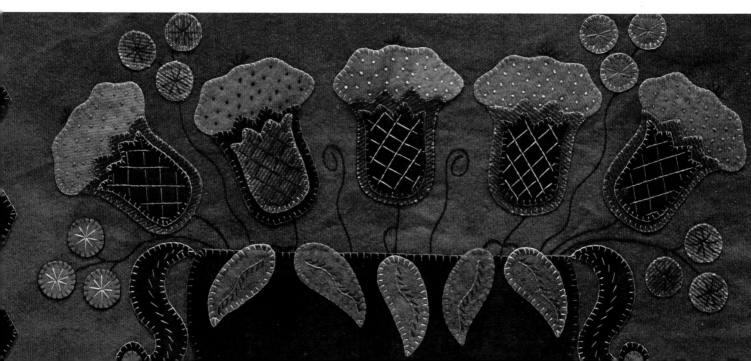

GETTING STARTED

Refer to Preparing the Wool Pieces (page 90) as needed for additional details on these steps.

1. Cut out the wool appliqué pieces using the patterns (pullout pages P3 and P4). Trim the zigzag edges of the background wool.

2. Lay out the whole project to be sure you have all of the wool pieces.

SEWING FUN

Refer to Stitching Your Project (page 90) for details on the blanket stitch and embroidery stitches.

1. Using the blanket stitch, position and appliqué all of the wool pieces, starting with the urn. Place the urn 1″ up from the bottom and center it from side to side, 8¼″ from each edge.

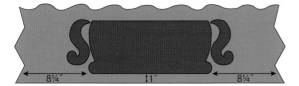

2. Add the embellishment stitches.

3. Using a steam iron on the wool setting, press the finished piece on the wrong side.

4. Appliqué the entire finished piece to a bolster cover, pillow cover, or any other item of your choosing.

> *note* If you would like to make a table rug rather than attach the wool piece to a bolster cover, cut a piece of wool or felt to the same size as the finished project. Layer the pieces and blanket stitch all the way around the outer edges.

Making a Bolster Cover

Because bolsters vary so much in size, specific directions are not included here. To make your own, measure the circumference of your bolster with a tape measure to see how wide the fabric needs to be, and add a couple of inches for seam allowances and breathing space. Measure the length and add 2″ or more for a hem, plus as much extra as you'd like to have at the open end. Use that figure for your length. Sew the side seams and hem the open end. Press the hem and sew a blanket stitch along the pressed edge. I used a linen blend from the home-decorating section of the fabric store for my bolster cover.

SEW MANY BERRIES

Finished sizes:

Sewing stool: 7″ diameter × 8½″

Scissor holder: 3½″ × 5″

Sewing basket: 5″ wide × 5″ long × 2½″ deep

June in Ohio means fresh, red, sweet, sun-ripened strawberries. They are a favorite in our house, and we eat them as long as they are available from the local fruit farms. As I pondered a project for some summer stitching, I thought there could be no better way to pay tribute to this delightful fruit than with a project inspired by its qualities. Strawberries are small but treasured, much like this diminutive sewing stool.

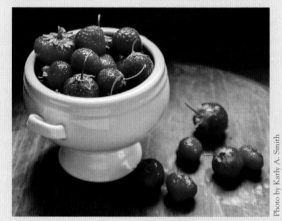

Strawberries—always a welcome summer treat

Photo by Karly A. Smith

With its petite height, this sewing make-do is a great project to fit into anyone's sewing space. This piece was inspired by a request from a friend who asked me to add something to a small stool as a donation to a fund-raising auction. At the last minute, I was inspired to turn it into a sewing caddy by stuffing the top wooly and adding the basket and scissor holder. It was a surprise project that turned out better than I could have imagined. I hope this piece brings you as much joy as it has me.

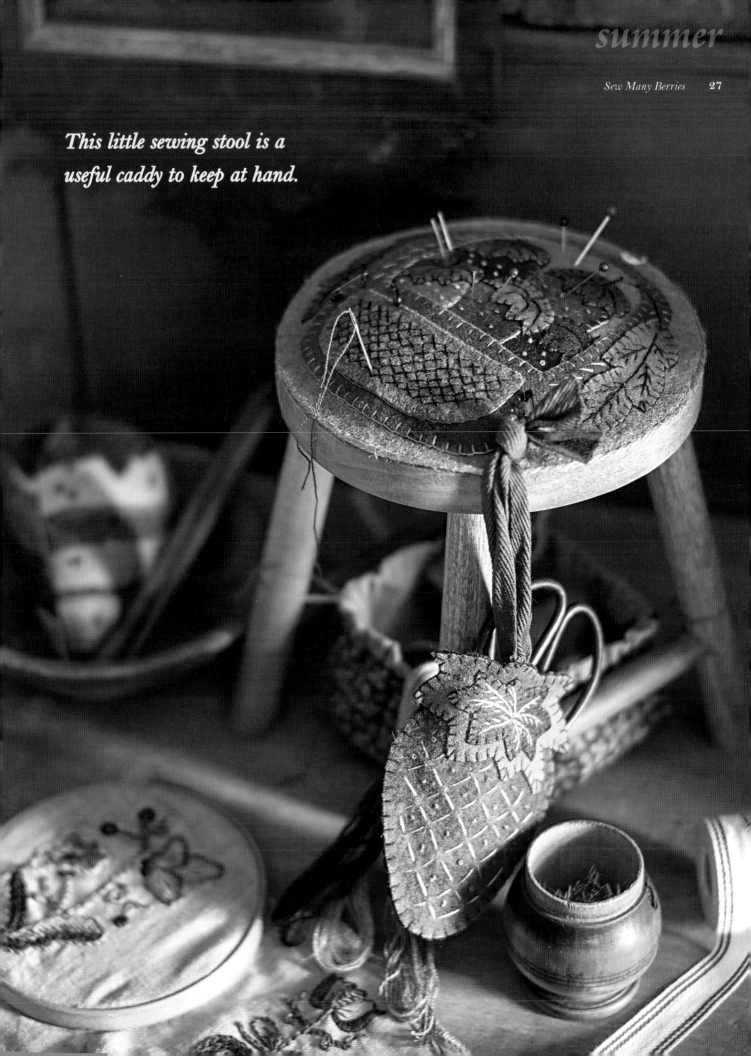

This little sewing stool is a useful caddy to keep at hand.

MATERIALS

Fabrics and other materials

Sewing stool

- 1 light brown wool square
 7½″ × 7½″ for background circle

- 1 medium brown wool rectangle
 5½″ × 6½″ for basket

- 1 green wool rectangle
 4″ × 6″ for basket bottom
 and strawberry tops

- 1 mustard wool rectangle
 3″ × 4½″ for leaves

- 1 light red wool square
 2″ × 2″ for 1 strawberry

- 1 medium red wool rectangle
 2″ × 4″ for 2 strawberries

- 1 dark red wool rectangle
 2″ × 4″ for 2 strawberries

- Embroidery floss: 1 skein
 each of mustard, dark
 brown, and antique white

- Wooden stool with 7″ round seat*

- Nonflammable contact cement*

- 1″ foam brush or cotton swab

- 1 yard of jute twine
 or jute ribbon*

- Fiberfill

Scissor holder

- 1 medium red wool rectangle
 3½″ × 4″ for strawberry

- 1 mustard wool rectangle
 2½″ × 4″ for strawberry top

- 1 green wool rectangle 2″ × 3″
 for inner strawberry top

- 1 red or black wool rectangle
 4″ × 5″ for backing

- 1 black wool rectangle
 3½″ × 4″ for scissor pocket

- Embroidery floss: 1 skein
 each of mustard, dark
 brown, and antique white

- 22″ length of twill tape,
 ribbon, or string

Sewing basket

- 2 cotton squares 11″ × 11″

- 1 chipboard square 5″ × 5″**

- 36″ length of string

*See Resources (page 95). I used twine
on the stool shown, but jute ribbon
could be used as well.*

**Available at office supply stores and
craft stores.*

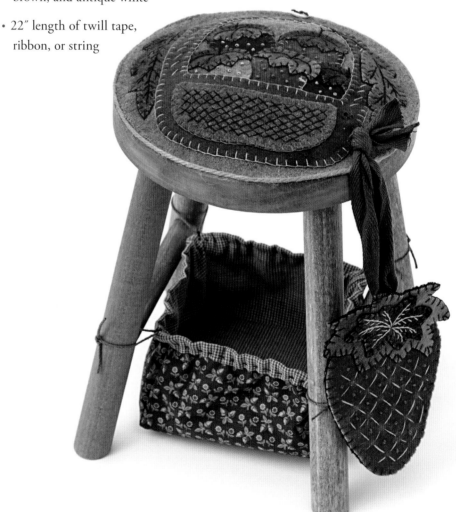

Stool Seat

GETTING STARTED

Refer to Preparing the Wool Pieces (page 90) as needed for additional details on these steps.

1. Cut out the wool appliqué pieces using the patterns (pages 32 and 33).

2. Lay out the whole project to be sure you have all of the wool pieces.

SEWING FUN

Refer to Stitching Your Project (page 90) for details on the blanket stitch and embroidery stitches.

1. Remove all of the wool pieces from the layout except the red wool strawberries.

2. Pin the berries in place and appliqué them using the blanket stitch.

3. Position the basket and then the leaf on the left side. Pin the leaf in place and remove the basket to stitch.

4. Pin the basket in place and finish stitching the rest of the pieces, adding any embellishment stitches.

5. Using a steam iron on the wool setting, press the whole finished piece on the wrong side.

GLUING FUN

1. Using a foam brush, run a thin line of the contact cement (referred to as glue) around the outside of the stool top, leaving a 3″ section without glue.

------------------ *Hint* ------------------

Before you glue the finished wooly to the stool, orient the wool piece so that the basket aligns with one of the openings between the legs of the stool.

2. Place the wool over the top of the stool and press in place. Let the glue dry for 30 minutes.

3. Once the glue is dry, stuff fiberfill in small amounts at a time between the finished wool appliqué and the stool top. Do not stuff too tight.

4. To close the opening, add a thin line of glue with the brush and finger-press closed. Hold for a few minutes.

5. Carefully trim any wool hanging over the edge of the stool top, if necessary. Be sure not to trim any of the appliqué.

6. Add the jute twine around the top edge by spreading the glue with a cotton swab onto 3″ of trim at a time and pressing it around the wooly on top.

7. Cut the twine to size and butt the edges together.

------------------ *Hint* ------------------

Where the two edges of the jute twine meet, you could add a button, bow, or any other kind of embellishment.

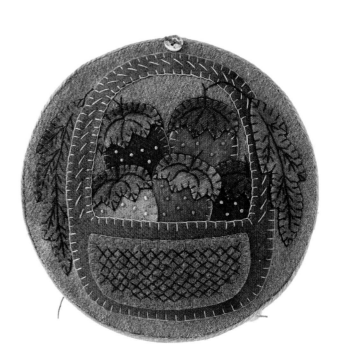

Scissor Holder

GETTING STARTED

Refer to Preparing the Wool Pieces (page 90) as needed for additional details on these steps.

1. Cut out the wool appliqué pieces using the patterns (page 32).

2. Lay out the whole project to be sure you have all of the wool pieces.

SEWING FUN

Refer to Stitching Your Project (page 90) for details on the blanket stitch and embroidery stitches.

1. Blanket stitch the strawberry and strawberry tops together, but do not stitch around the outside edges of the strawberry and strawberry top.

2. Add the embellishment stitches.

3. Pin together the strawberry, the wool backing piece, and the scissor pocket. Blanket stitch around the outer edges, and then blanket stitch the top edge of the scissor pocket.

4. Using a steam iron on the wool setting, press the finished piece on the wrong side.

5. Sew the twill tape or ribbon to the back of the scissor holder along the top edge.

6. Tie a bow or knot at the top and pin it to the stool top with a small safety pin.

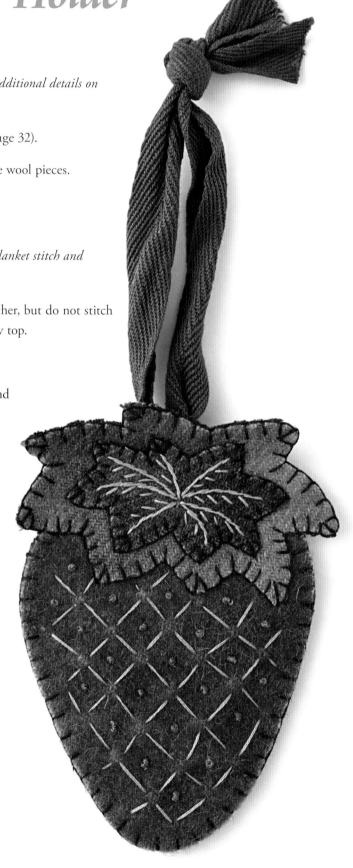

Sewing Basket

GETTING STARTED

Cut a 3″ × 3″ square out of each corner of the 2 cotton pieces.

SEWING FUN

1. To make a basket out of each piece, sew the 2 sides of each corner with right sides together by machine or by hand. Use a ¼″ seam allowance and a straight stitch or running stitch.

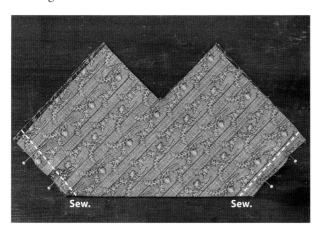

2. Turn the outer basket right side out.

3. Place the chipboard square into the bottom of the right-side-out basket. Place the inside-out basket on top of the chipboard, matching up the corners of both baskets.

4. To create a hem along the top edges of the basket, fold down ¼″ twice and pin as you go all the way around the basket.

5. With 2 strands of floss or thread, sew a gathering stitch along the turned-down edge.

6. Pull the gathering stitch to fit where you would like the basket before tying it off.

7. Cut the 36″ length of string into 4 pieces 9″ long and sew a piece to each corner of the basket.

8. Tie the basket to the stool.

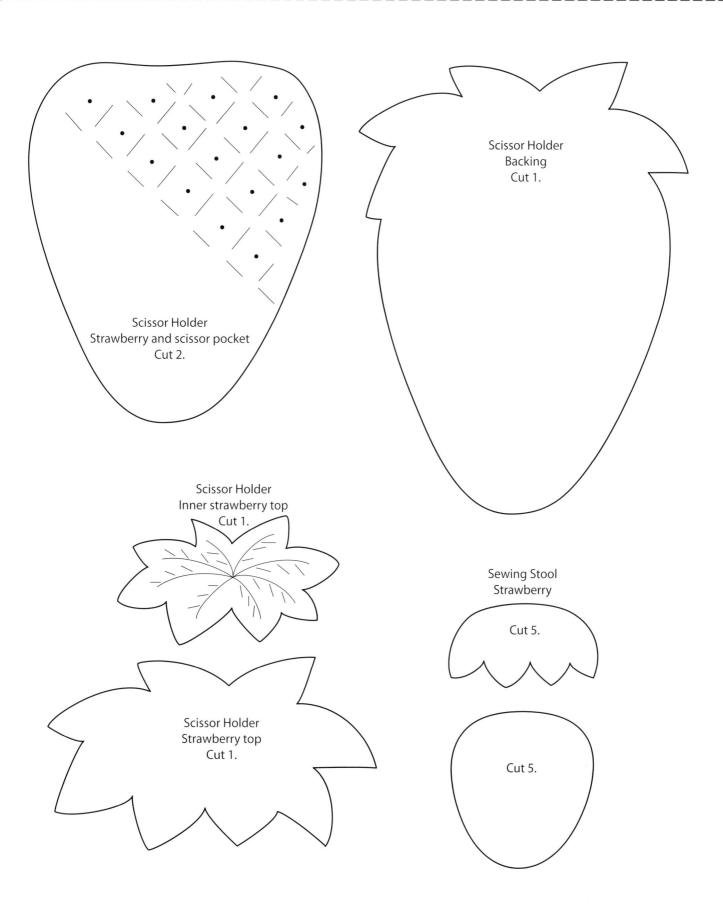

Scissor Holder
Strawberry and scissor pocket
Cut 2.

Scissor Holder
Backing
Cut 1.

Scissor Holder
Inner strawberry top
Cut 1.

Sewing Stool
Strawberry

Cut 5.

Scissor Holder
Strawberry top
Cut 1.

Cut 5.

Sewing Stool

IN THE PURSUIT OF PICNICS

Finished blanket carrier: 16″ × 33″

*I*f you are looking for patriotic inspiration, look no further than the Fourth of July with its parades, fireworks, cookouts with friends, and flag waving. Every year I design several pieces to mark the occasion of our nation's birth. There is no end to the combinations of motifs, and even with a limited red, white, and blue color palette, I never have enough time to stitch up all of the designs that I have sketched out.

Enjoy a summer's picnic!

This project, you will find, produces a versatile finished piece that you see here as a blanket carrier but that could just as easily double as a receptacle for your sewing projects, books, or even bounty from your garden. The motif that is stitched is my interpretation of an old-time rosette, worn to mark the patriotic celebrations of our early nation. Whether you are pursuing picnics or just going about your everyday errands, this carrier can be useful as well as patriotically pleasing.

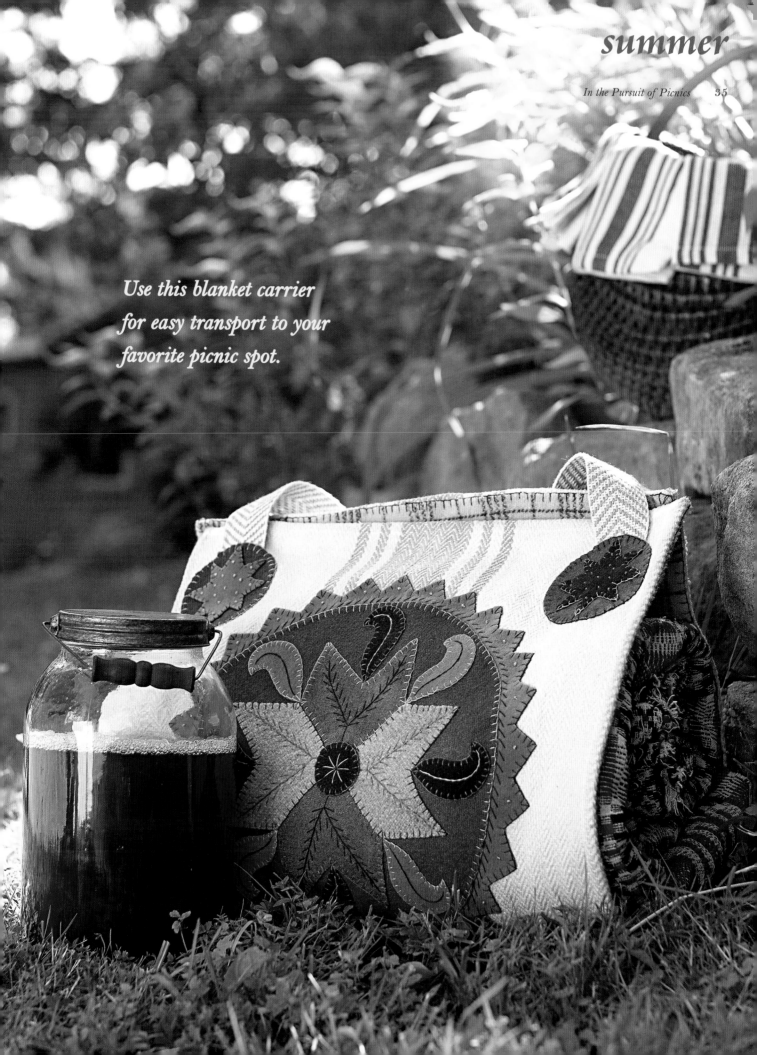

Use this blanket carrier
for easy transport to your
favorite picnic spot.

MATERIALS

Fabrics

- 1 heavy linen or cotton rectangle 17″ × 34″ for background*

- 1 wool rectangle 16″ × 33″ for backing

- 1 mustard wool rectangle 13″ × 16″ for large rosette, 4 petals, and 2 stars

- 1 red wool rectangle 11″ × 17″ for large circle, 2 small circles, and inner ribbons

- 1 blue wool square 12″ × 12″ for 2 star points, 2 small circles, and ribbons

- 1 dark brown wool rectangle 6″ × 7″ for 4 petals, flower center, and 2 stars

- 1 beige wool rectangle 4″ × 8″ for 2 star points

Other materials

- Embroidery floss: 1 skein each of dark brown, antique white, and mustard

- 1½ yards of 1⅝″-wide upholstery tape**

I used a heavyweight cotton that I had on hand and dyed it with coffee. You can use a toweling fabric for a similar look.

**See Resources (page 95).*

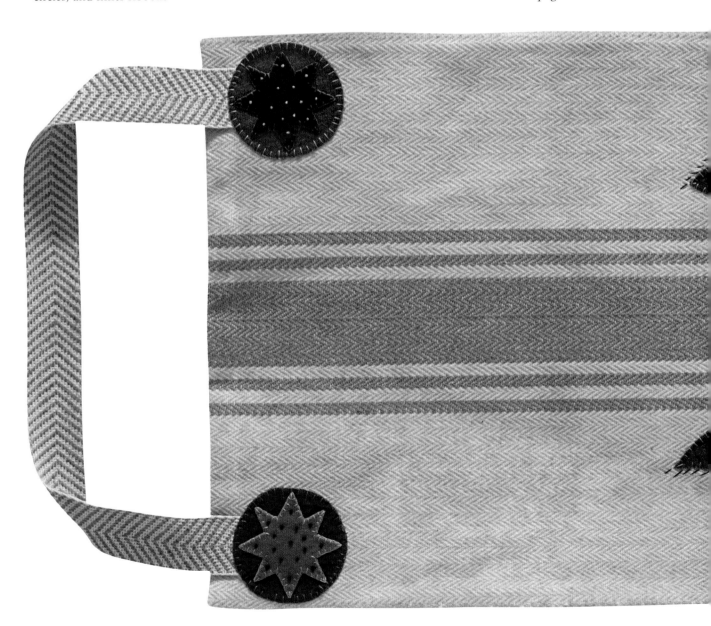

GETTING STARTED

Refer to Preparing the Wool Pieces (page 90) as needed for additional details on these steps.

1. Cut out the wool appliqué pieces using the patterns (pullout page P2).

2. Lay out the whole project to be sure you have all of the wool pieces.

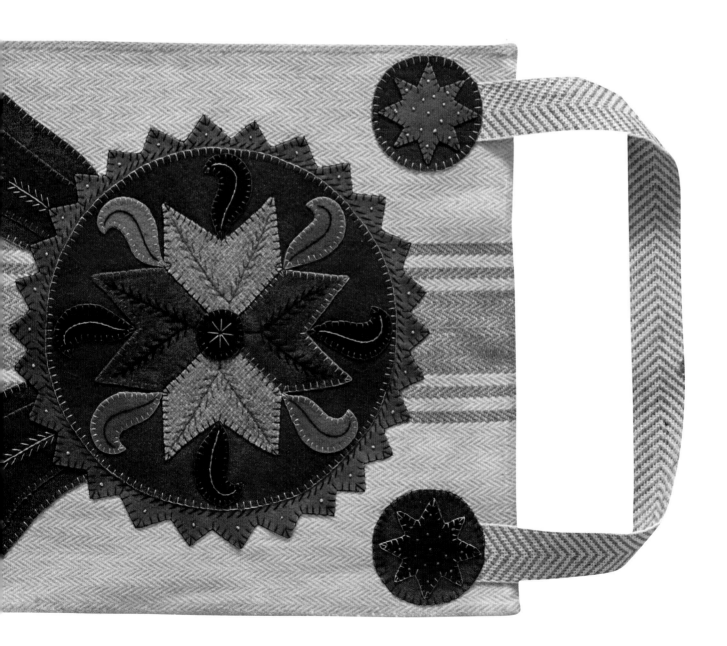

SEWING FUN

Refer to Stitching Your Project (page 90) for details on the blanket stitch and embroidery stitches.

1. Using the blanket stitch, appliqué all the large rosette pieces to the background.

2. Add the embellishment stitches.

3. Cut the upholstery tape into 2 pieces 26″ long and place 1 piece on each end of the background, as shown. Pin in place. Sew the ends of the tape securely to the background by machine or by hand.

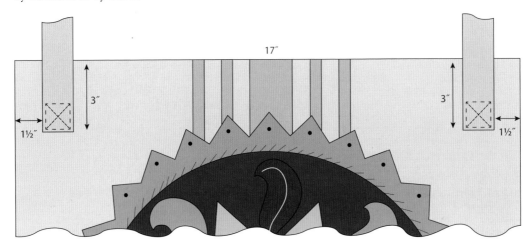

4. Pin the wool circles over the ends of the twill tape and blanket-stitch in place.

5. Add the stars and embroider the French knots.

6. Using a steam iron on the wool setting, press the whole finished piece on the wrong side.

7. Lay out the backing wool on the wrong side of the finished piece.

8. Fold the edges of the linen or cotton over ¼″ twice all the way around and pin the backing wool to the wrong side of the background as you go.

9. Blanket stitch all the way around to finish.

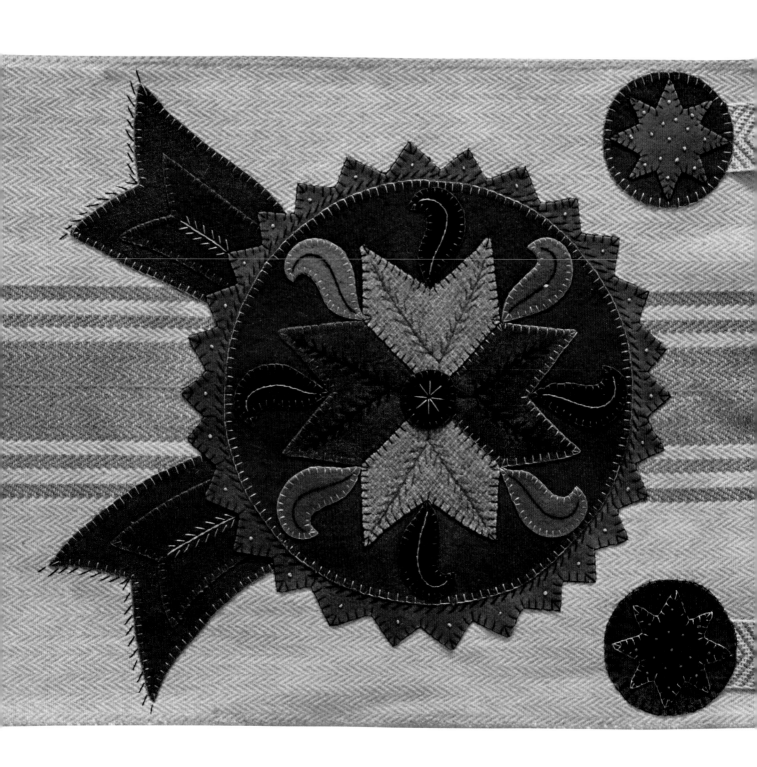

ON THE LINE

Finished clothespin pocket: 13¼″ × 10″

Those of you who really know me are aware by now of how little regard I pay to housework. It's not that I don't do it; it's just that I would prefer not to! Yet laundry is the one household duty to which I am drawn. I really enjoy this task, especially in the summer, when I can hang my washing out on the clothesline. There is nothing like the scent of freshly dried sheets and clothes that have spent the day snapping in the breeze.

Photo by Bruce P. Smith

Sweetened baskets of laundry fresh from the line

Some of my earliest childhood memories of both my mother and grandmother are of them hanging their washing out on the clothesline. While my mother got her clothespins from a basket, my grandmother had a clothespin bag that hung on the line for easy reach. This project is my nod to those times I spent helping them hang their washing by handing them clothespins as needed. Even if you only have a small yard, patio, or balcony, it's worth it to hang out just one sheet to get that fresh-air smell that cannot be bottled.

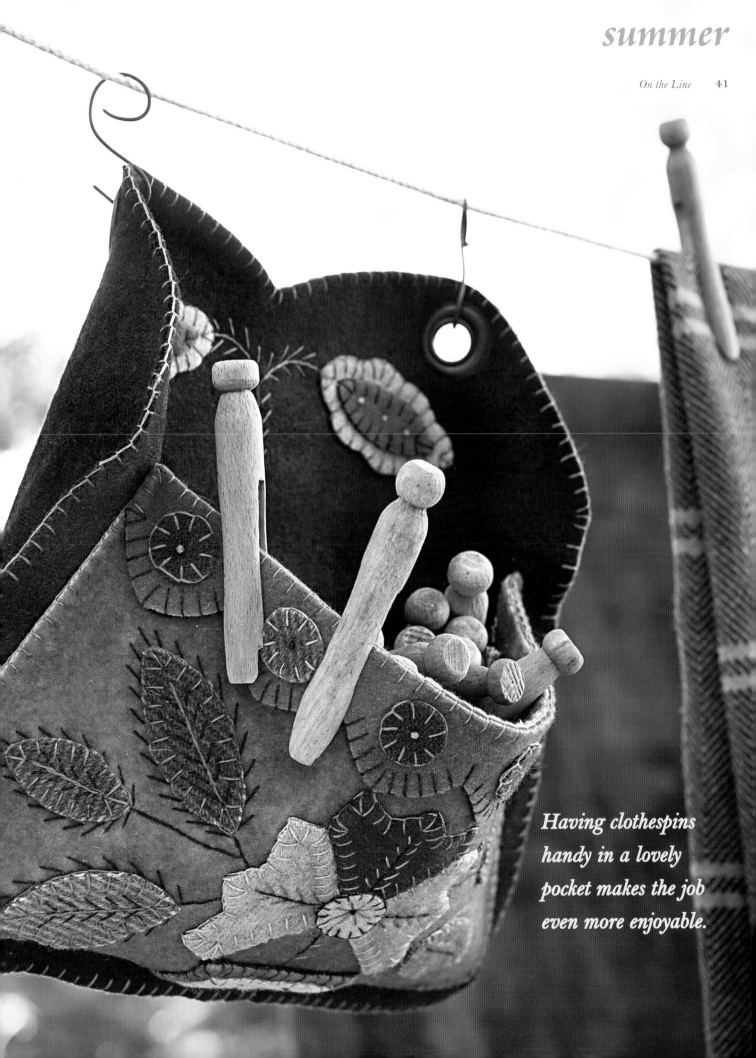

Having clothespins handy in a lovely pocket makes the job even more enjoyable.

MATERIALS

Fabrics

- 2 dark brown/green wool rectangles 11″ × 14″ for background and backing

- 1 tan/mustard wool rectangle 7″ × 12″ for pocket

- 1 dark orange wool rectangle 2½″ × 3″ for 1 flower petal

- 1 medium orange wool rectangle 3½″ × 11″ for pocket border, flower pot, and inner petals

- 1 antique-white wool rectangle 4″ × 5″ for inner flower pot, flower center, and flower petals

- 1 light orange wool rectangle 2½″ × 5″ for 2 flower petals

- 1 dark blue wool rectangle 3″ × 6″ for 4 leaves

- 1 light blue wool rectangle 3″ × 4″ for 2 leaves and 3 small circles

- 1 dark brown wool rectangle 1″ × 3″ for 3 small circles

Other materials

- Embroidery floss: 1 skein each of dark brown, antique white, and mustard

- Grommet tool and 2 black ½″ grommets (*optional*)

- Heavy-gauge wire (*optional*)

------------------ **Hint** ------------------

If you do not have access to a grommet tool or wish to use another method for hanging the bag, you can sew two rings to the top of the bag, add two large buttonholes to the top, or just stitch a twill tape hanger to the top of the finished piece.

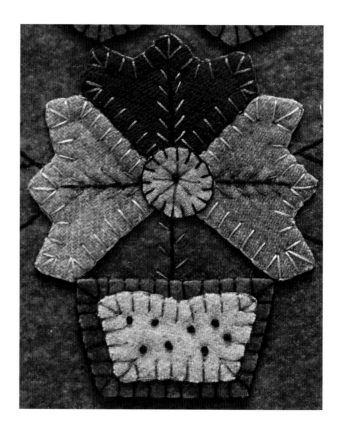

GETTING STARTED

Refer to Preparing the Wool Pieces (page 90) as needed for additional details on these steps.

1. Cut out the wool appliqué pieces using the pattern (pullout page P1).

2. Lay out the whole project to be sure you have all of the wool pieces.

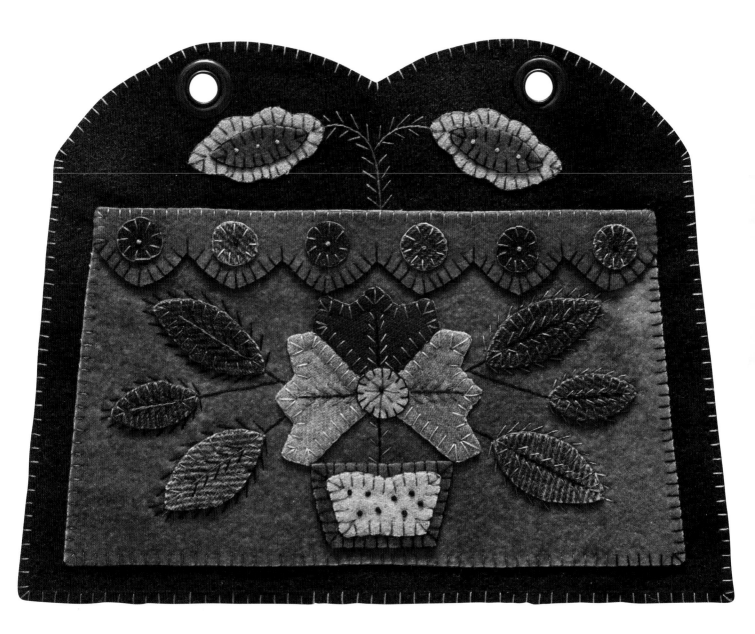

SEWING FUN

Refer to Stitching Your Project (page 90) for details on the blanket stitch and embroidery stitches.

1. Using the blanket stitch, appliqué all of the wool pieces to the pocket.

2. Add the embellishment stitches.

3. Using a steam iron on the wool setting, press the finished pocket on the wrong side.

4. Center the finished pocket on the background wool, ¾″ from the bottom.

5. Appliqué the pocket to the background wool, being sure to leave the top open.

6. Appliqué the wool pieces to the top of the background.

7. Add the embellishment stitches.

8. Pin together the finished piece and the wool backing piece, and blanket stitch all the way around the outside edges to finish.

9. Add grommets, or use any of the other hanging methods (see Hint, page 42).

10. Make S-hooks using heavy-gauge wire, or loop twill tape through the grommets.

Fill with clothespins, and hang out the wash!

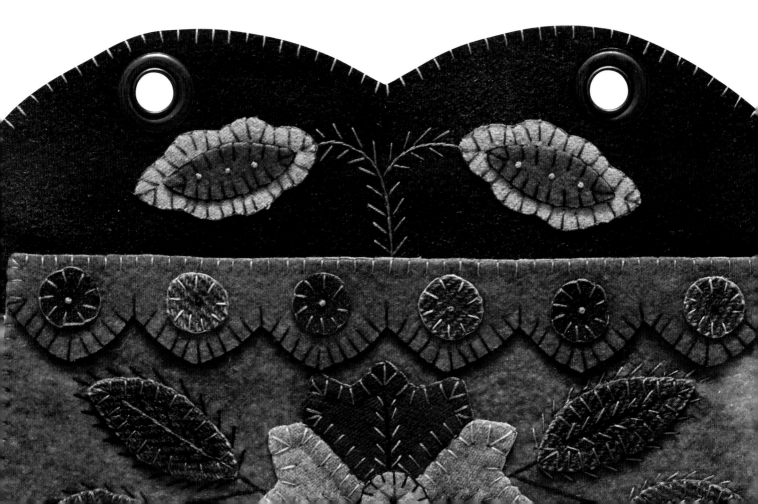

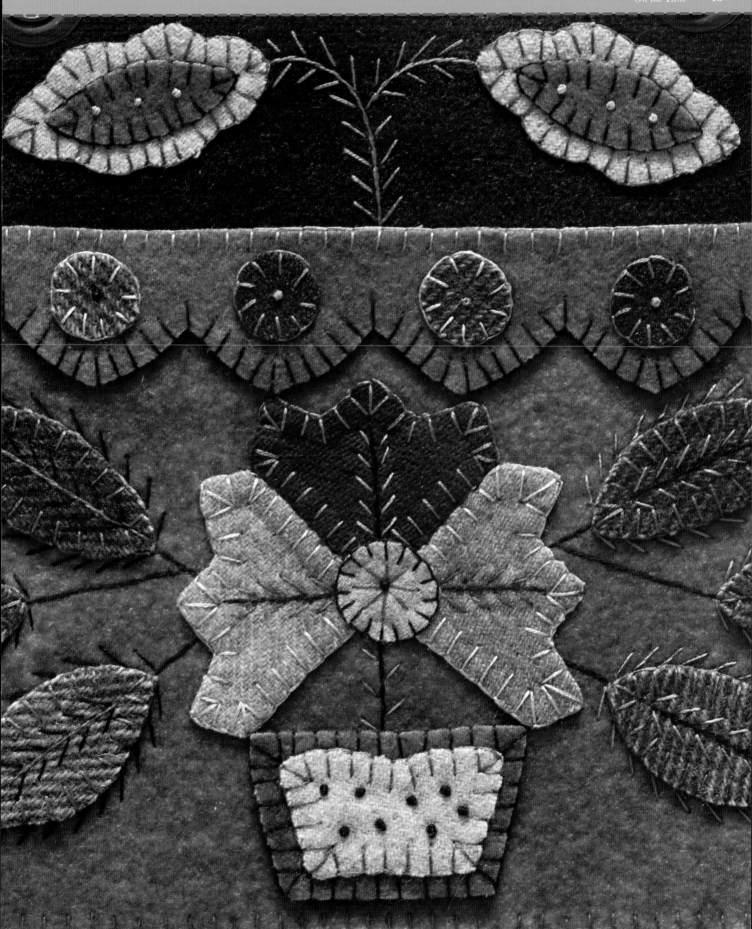

SEPTEMBER'S STORAGE

Finished sizes:

Round tulip box: 5″ deep × 10″ diameter

Oval bird box: 4″ deep × 8¾″ wide × 6¾″ long

Oval chicken box: 4½″ deep × 10½″ wide × 8″ long

Summer begins to wane, and it is at this juncture in the year that I start collecting items I want near me in the coming winter months. Items to be used throughout the next two seasons, in my work as well as in my home, need to be carefully stored until they become necessary. It's important to have plenty of storage, which can be both beautiful and utilitarian.

Boxes are among my favorite items to collect. There is no end to their practical usefulness, but that doesn't mean they have to be boring or unrefined. My boxes run the range from brown cardboard for my shipping containers to wonderful old, painted wooden boxes with hand-forged clasps. One of my favorites is a small wooden box with a beautiful antique wallpaper interior. The outside has just a plain varnish, but when you open it, another world is revealed in the color and intricacy of the interior patterns.

Boxes for protecting precious items

Photo by Karly A. Smith

These project boxes are the opposite. Decorative and colorful on the outside, they are meant to be simply serviceable on the inside. Mine will be packed with dried lavender for small pillows, old wooden spools of string, and perhaps snippets of vintage fabrics for future projects. Any stitcher would have an endless list of items that could find their way into these wooly boxes.

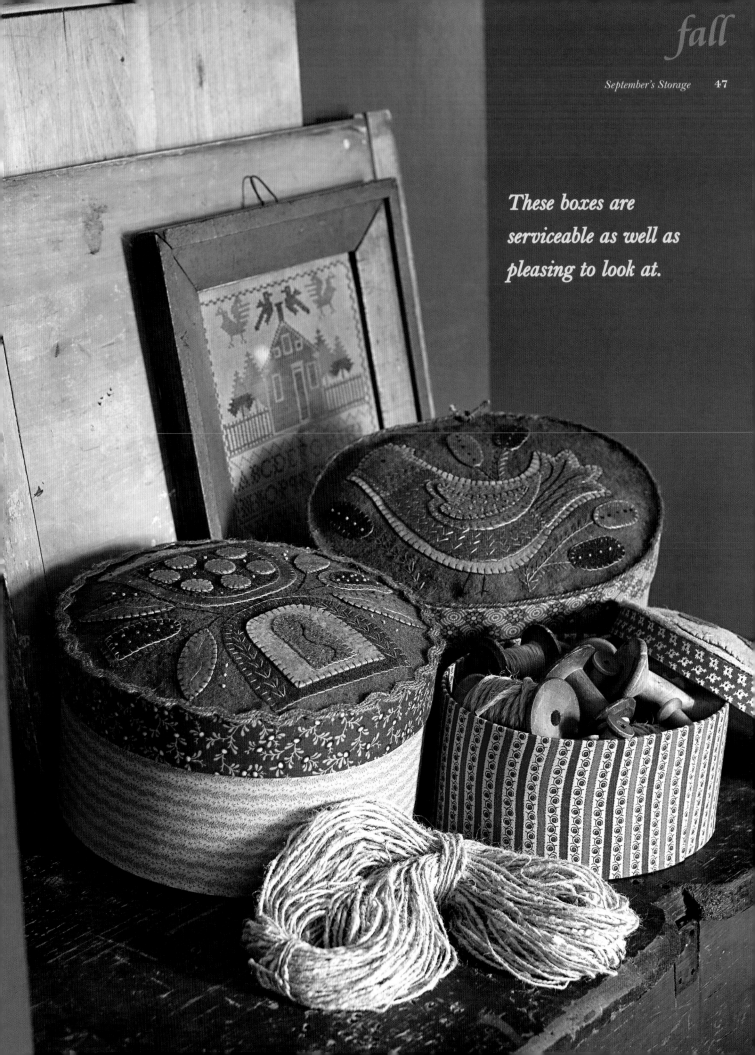

These boxes are serviceable as well as pleasing to look at.

MATERIALS

note Papier-mâché boxes vary in size. Purchase the boxes and measure them before cutting the fabrics. You may need to adjust the dimensions of the cotton fabrics for the box and lid. For the box base, add 1½″ to the height of the box and 1½″–2″ to the circumference for your cotton rectangles. Compare the lid to the background pattern as well, and adjust the size of the background circle or oval if necessary.

Fabrics and other materials

Round tulip box

- 1 cotton rectangle 6½″ × 33″ for box base

- 1 cotton rectangle 2″ × 33″ for box lid base

- 1 dark mustard wool square 10½″ × 10½″ for top background

- 1 dark brown wool rectangle 4½″ × 9½″ for large tulips and small tulip centers

- 1 dark orange wool rectangle 4″ × 5″ for large tulip

- 1 light orange wool square 3″ × 3″ for tulip dots

- 1 green wool rectangle 4″ × 5″ for small tulips and large tulip center

- 1 gold wool square 3½″ × 3½″ for large tulip

- 1 light mustard wool rectangle 3″ × 5″ for leaves

- 1 tan wool rectangle 1″ × 5″ for tulip top

- Embroidery floss: 1 skein each of dark brown, antique white, and mustard

- 1 round papier-mâché box 5″ deep × 10″ diameter

- Nonflammable contact cement*

- 1″ foam brush for gluing

- Fiberfill

- 1 yard of jute ribbon*

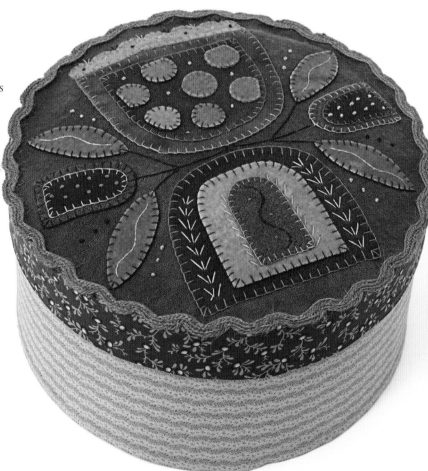

Oval bird box

- 1 cotton rectangle 5½″ × 28″ for box base

- 1 cotton rectangle 2″ × 28″ for lid base

- 1 brown wool rectangle 8″ × 10″ for top background

- 1 antique-white wool rectangle 7″ × 9″ for scalloped oval

- 1 dark orange wool rectangle 2″ × 3″ for bird body

- 1 green wool rectangle 3″ × 4″ for heart leaf and paisley leaves

- 1 mustard wool rectangle 2″ × 3″ for oval flower and bud

- 1 brown wool square 3″ × 3″ for heart accents and bird wing

- 1 blue wool rectangle 2″ × 3″ for flower center and bird tail

- Embroidery floss: 1 skein each of dark brown, antique white, and mustard

- 1 oval papier-mâché box 4″ deep × 8¾″ wide × 6¾″ long

- Nonflammable contact cement*

- 1″ foam brush for gluing

- Fiberfill

- 1 yard of jute ribbon*

Oval chicken box

- 1 cotton rectangle 6″ × 32″ for box base

- 1 cotton rectangle 2″ × 32″ for lid base

- 1 dark mustard wool rectangle 8½″ × 11″ for top background

- 1 light mustard wool rectangle 6½″ × 8″ for chicken

- 1 dark orange wool rectangle 4″ × 5″ for chicken body

- 1 brown wool rectangle 4″ × 5″ for head and wing

- 1 blue wool rectangle 4″ × 5″ for tail and inner wing

- 1 dark brown wool rectangle 3″ × 4″ for 3 flower buds

- 1 medium orange wool rectangle 2″ × 3″ for 2 flower buds

- Embroidery floss: 1 skein each of dark brown, antique white, and mustard

- 1 oval papier-mâché box 4½″ deep × 10½″ wide × 8″ long

- Nonflammable contact cement*

- 1″ foam brush for gluing

- Fiberfill

- 1 yard of jute twine or ribbon*

See Resources (page 95).

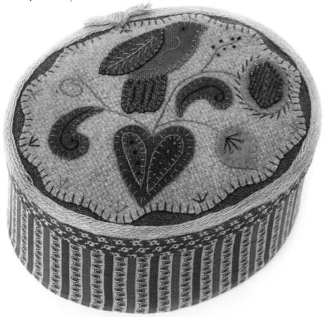

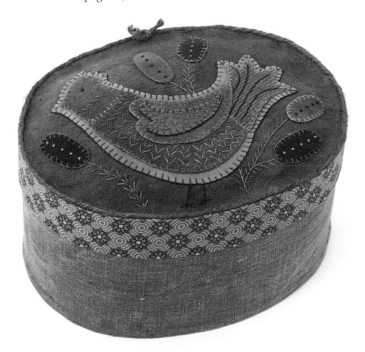

GETTING STARTED

Refer to Preparing the Wool Pieces (page 90) as needed for additional details on these steps.

1. Cut out the wool appliqué pieces using the patterns of your choice (pullout page P1).

2. Lay out the whole project to be sure you have all of the wool pieces.

SEWING FUN

Refer to Stitching Your Project (page 90) for details on the blanket stitch and embroidery stitches.

1. Using the blanket stitch, appliqué all of the wool pieces to the box top background.

2. Add the embellishment stitches.

3. Using a steam iron on the wool setting, press the finished box top on the wrong side.

GLUING FUN

There are several ways to attach fabric to papier-mâché boxes. These are the instructions for the way I do it, using the contact cement. The cement (referred to as glue) leaves darkened areas on the fabric instead of drying clear, giving the work a desirable time-worn look.

1. Iron the cotton fabric flat.

2. Lay the cotton fabric with the right side down. Using the foam brush, lightly add a ¼″ line of glue along what will become the bottom of the cotton fabric. Turn up a ¼″ hem and press flat to dry.

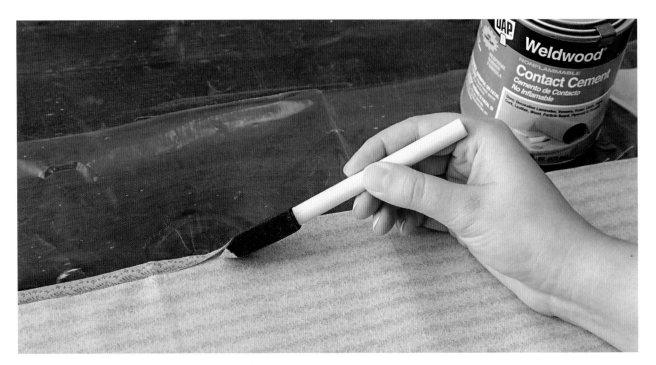

--- *Hint* ---

This glue works quickly and sticks well, so you do not have to use much. Just apply the glue in small quantities.

3. Apply a smooth, light layer of glue to the outside of the box, about 3″ at a time.

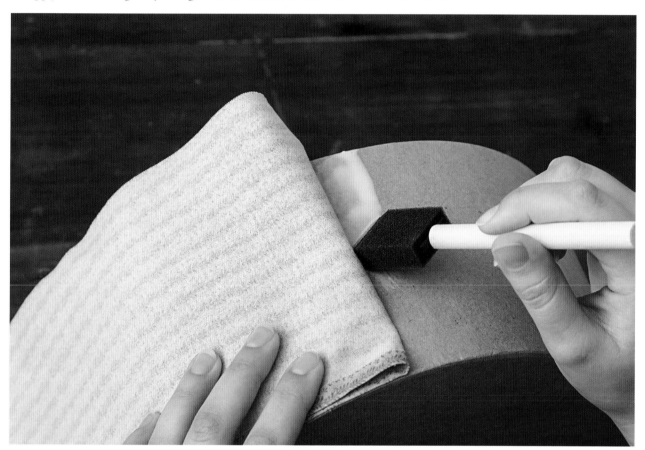

------------------ **Hint** ------------------

Do not glue the first 1″ of fabric to the box. This will be part of the overlapped area that will be stitched.

4. With the hem lined up with the bottom, carefully press the fabric onto the box where you have applied the glue, smoothing it out as you go.

5. Continue all the way around the box.

6. Leave another 1″ unglued, overlapping the 1″ you left unglued at the beginning.

7. Trim the fabric if necessary.

8. Turn under the outer edge of the top layer and pin it to the bottom layer.

9. Blanket stitch the turned-under fabric to the bottom layer, beginning at the top and stitching to the bottom.

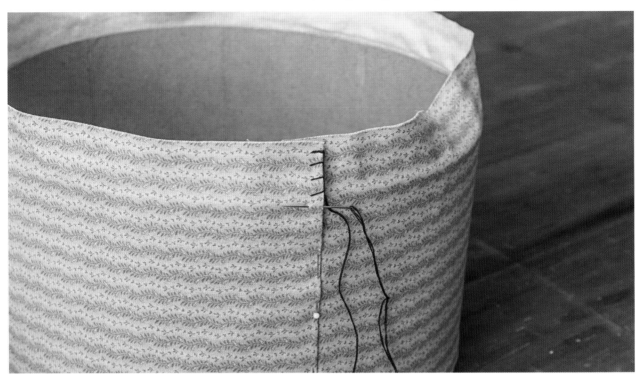

10. Apply a light coating of glue to the inside top edge of the box no wider than the excess fabric.

11. Fold the excess fabric over the top of the box and press it into the glue, smoothing it all the way around.

12. To cover the lid, repeat Steps 3–11, but begin by gluing the fabric to the lower edge of the lid. Fold the excess over the top of the lid where it will be covered by the finished wool piece.

13. Let the box and lid dry for 10–15 minutes.

14. Add ¼″ of glue around the top of the box, leaving a 3″ opening for fiberfill.

15. Align the front of the finished wool appliqué piece with the section of the lid that you want to be the front, and press the edges into the glue. Hold it down for a minute so the glue can catch and hold.

16. Let the top dry for 10–15 minutes.

17. Add small amounts of the fiberfill at a time through the 3″ opening until the top of the box has a rounded shape. I used an unsharpened pencil to help with stuffing.

18. Glue the 3″ opening closed.

19. Add trim around the top wooly by putting glue on the back side of the trim in 3″ increments and pressing it down around the lid as you go.

20. Cut the trim to size as needed and butt the ends together.

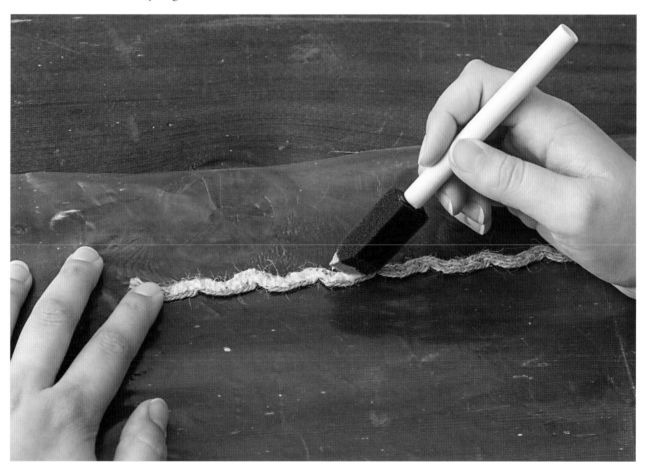

-- **Hint** --

You may want to add other embellishments to the top of the box where the trim comes together. I added a knotted piece of trim, but you could also make a bow or add a button.

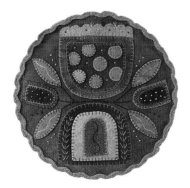 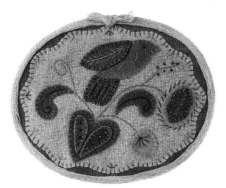 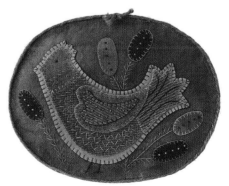

PILLOWS FROM THE PATCH

Finished sizes:

Green pumpkin pillow: 11″ × 11″

Orange pumpkin pillow: 15″ × 9½″

*O*h, October, my favorite month of the year! Just the sound of its name makes my heart beat faster and my hands twitch to get creating. From the vivid colors of the turning leaves to the smell of dried grass and the flights of flocking birds, I just cannot get enough of the splendor of autumn. This is the time of year my smoky fire burns under the kettles of boiling black walnuts, giving me their wonderful brown hues to use as dyes and add to my stash of fabrics. It is also the time to scour the country markets and stands for dried corn, pumpkins, squash, and other fruits of the season.

The season's vibrant gifts for inspiration

Photo by Karly A. Smith

Every year, I find myself once again looking for the perfect pumpkins for my porch and walkways. These pumpkins usually are not perfect at all. I like them lopsided, with spots, and always with stems. These wooly pumpkins are my way of bringing them into the house without the fear that they will rot suddenly and leave a terrible mess in an antique bowl or basket. You could make one, or both, or a pile of them to mound in a large basket. They will be a cherished fall addition to any home.

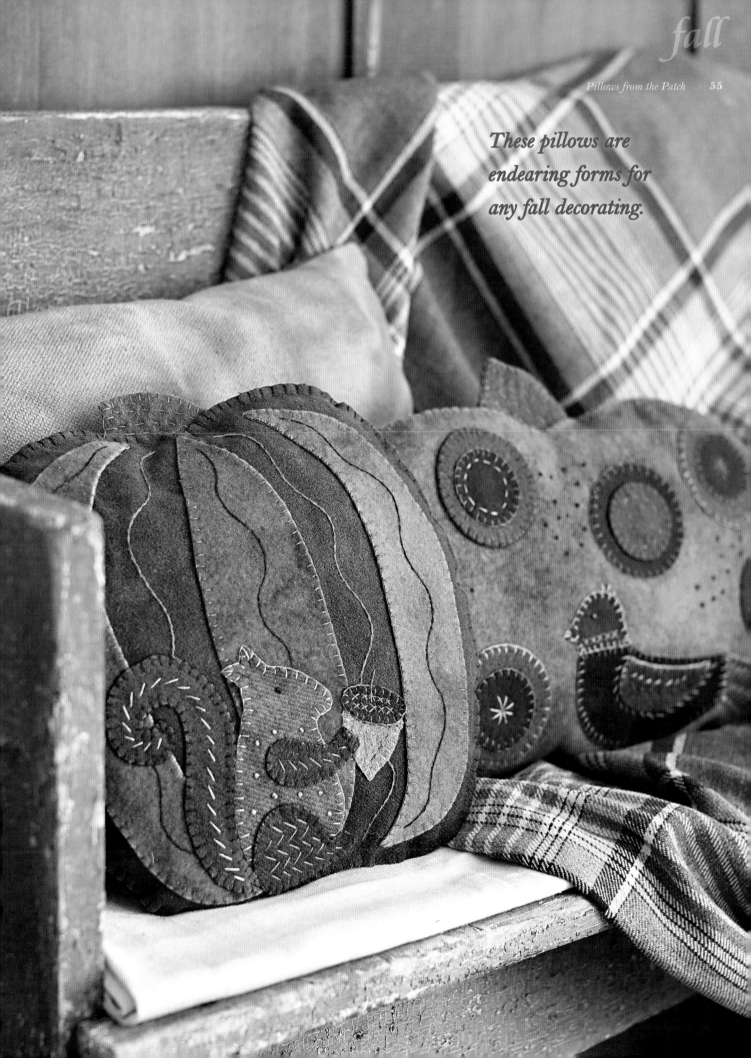

These pillows are endearing forms for any fall decorating.

MATERIALS

Fabrics

Green pumpkin pillow

- 1 dark green wool rectangle 11″ × 12″ for pumpkin

- 1 wool rectangle 11″ × 12″ for pillow back

- 1 light green wool rectangle 8″ × 9½″ for pumpkin stripes

- 1 mustard wool rectangle 5″ × 7″ for squirrel

- 1 medium brown wool rectangle 2″ × 2½″ for stem

- 1 dark brown wool scrap 1″ × 2″ for acorn cap

- 1 tan wool scrap 1½″ × 1½″ for acorn

Orange pumpkin pillow

- 1 orange wool rectangle 10″ × 16″ for pumpkin

- 1 wool rectangle 10″ × 16″ for pillow back

- 1 medium brown wool rectangle 5″ × 9″ for stem, 3 large spots, and 3 small spots

- 1 dark green wool rectangle 5″ × 8″ for 3 large spots and 3 small spots

- 1 black wool rectangle 3″ × 5″ for bird body

- 1 red wool rectangle 2″ × 3″ for bird wing

- 1 dark brown wool rectangle 2½″ × 4½″ for bird head and tail

Other materials

- Embroidery floss: 1 skein each of dark brown, antique white, and mustard

- Fiberfill

- Wool scraps

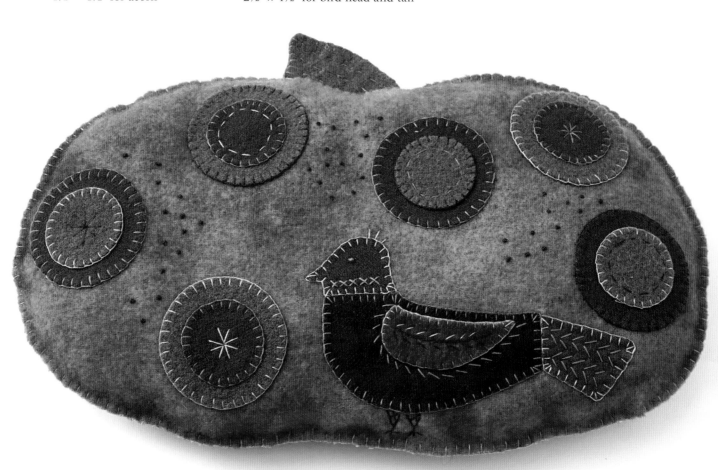

GETTING STARTED

Refer to Preparing the Wool Pieces (page 90) as needed for additional details on these steps.

1. Cut out the wool appliqué pieces using the patterns (pullout page P3). Cut out the wool backing piece so that it includes the stem.

2. Lay out the whole project to be sure you have all of the wool pieces.

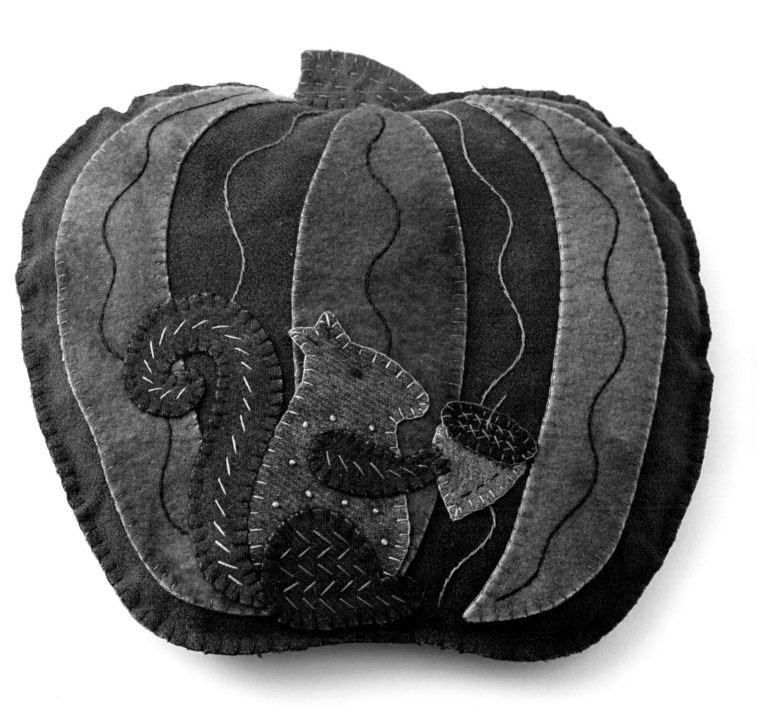

SEWING FUN

Refer to Stitching Your Project (page 90) for details on the blanket stitch and embroidery stitches.

1. Using the blanket stitch, appliqué all of the wool pieces to the pumpkin.

2. Add the embellishment stitches.

3. Using a steam iron on the wool setting, press the finished pumpkin on the wrong side.

4. Line up the finished pumpkin with the corresponding pillow back and pin together.

5. Insert the stem between the layers at the top of the pumpkin and pin securely.

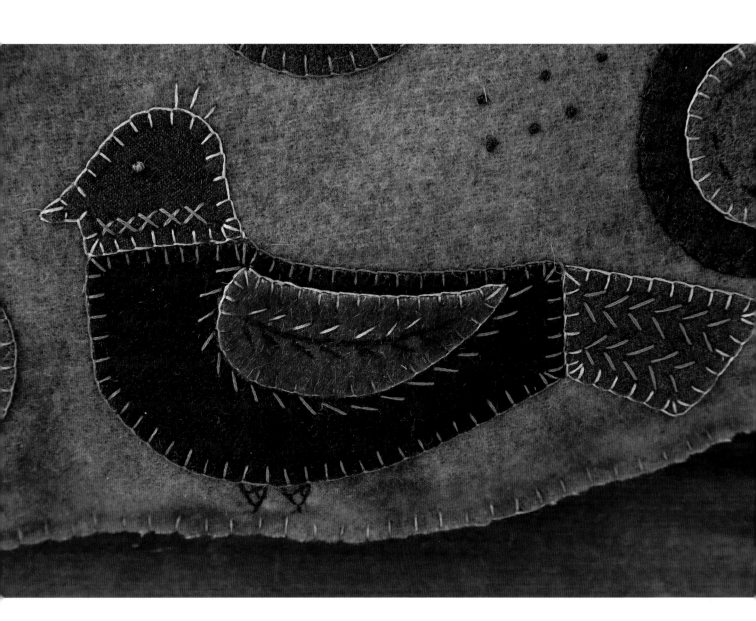

6. Blanket stitch all the way around the pumpkin and stem, leaving a 3″ opening at the bottom for the fiberfill.

7. Add the fiberfill to the pillow until there is approximately 2″ of space at the bottom.

8. Add wool scraps to fill the space at the bottom of the pillow. (This gives it some weight.)

9. Blanket stitch the opening closed.

10. Add embellishment stitching to the stem.

AUTUMN ABUNDANCE

Finished wallhanging: 17½" × 21"

The year is moving swiftly to a close, and it's time to take stock and be thankful for the provisions of the garden, whether your own or someone else's. We have friends who always share what they have grown, and we in turn like to return the favor. Our efforts in vegetable gardening have not gone very well, however,

The abundance of the season cultivates a time of sharing.

because we have a very shaded yard and poor soil due to all of the black walnut trees and clay. We find other ways to share a bounty, such as through baked goods or having friends to the house. Hospitality is something that we value, and decorating a seasonal table for the holidays is especially fun.

This wooly wallhanging can be a focal point for a wall in any room. With a vibrant depiction of autumn's harvest, its appearance is a bold addition to fall decor. Even with its muted palette and softer tones, this piece has a rich quality that comes from the form as well as the colors.

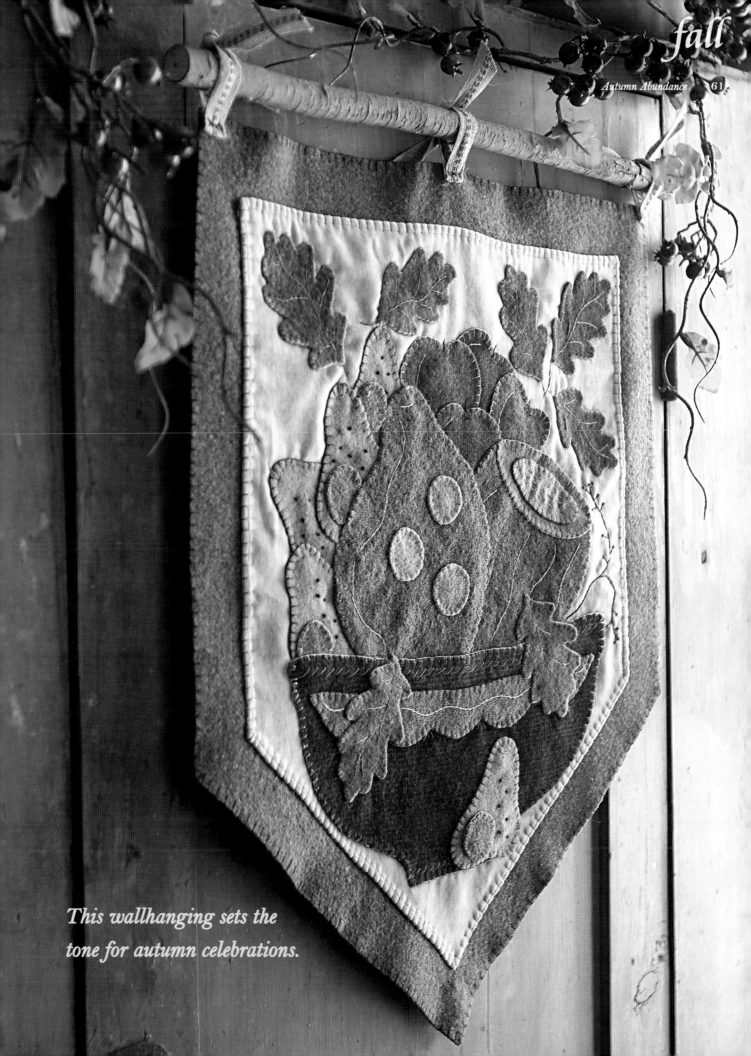

This wallhanging sets the tone for autumn celebrations.

MATERIALS

Fabrics

- 1 medium green wool rectangle 18″ × 22″ for backing

- 1 light mustard velvet rectangle 15″ × 18½″ for background

- 1 dark brown wool rectangle 6″ × 13″ for bowl

- 1 blue wool rectangle 7½″ × 12″ for 2 squash

- 1 mustard wool rectangle 8″ × 10″ for squash center and pears

- 1 orange wool rectangle 2″ × 5″ for squash center

- 1 red wool rectangle 5″ × 6½″ for apples

- 1 light blue wool rectangle 2″ × 5″ for spots on squash

- 1 light green wool rectangle 4″ × 10″ for 4 oak leaves

- 1 dark green wool rectangle 4″ × 9″ for 3 oak leaves

- 1 medium green wool rectangle 3 ″ × 12″ for bowl scallop and pear spots

Other materials

- Embroidery floss: 2 skeins each of dark brown, antique white, and mustard

- 3 pieces of jute ribbon, each 12″ long*

See Resources (page 95).

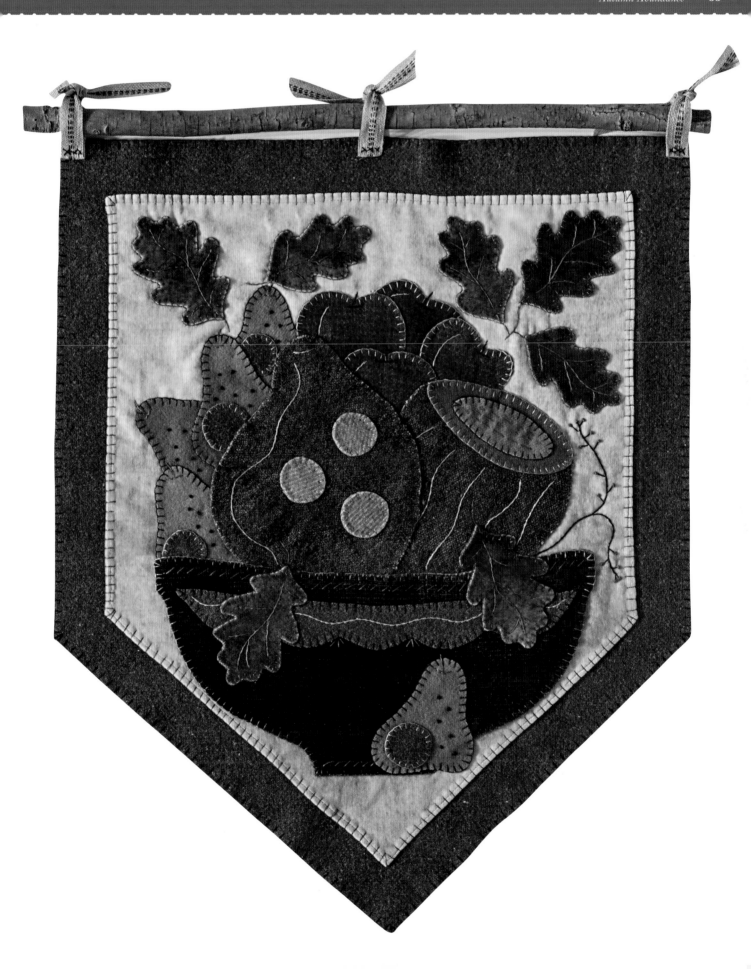

GETTING STARTED

Refer to Preparing the Wool Pieces (page 90) as needed for additional details on these steps.

1. Cut out the wool appliqué pieces using the pattern (pullout page P2).

2. Cut out the velvet background, adding ¼″ all around the pattern for turning under.

3. Lay out the whole project to be sure you have all of the wool pieces.

SEWING FUN

Refer to Stitching Your Project (page 90) for details on the blanket stitch and embroidery stitches.

1. Using the blanket stitch, appliqué all of the wool pieces to the velvet background.

2. Add the embellishment stitches.

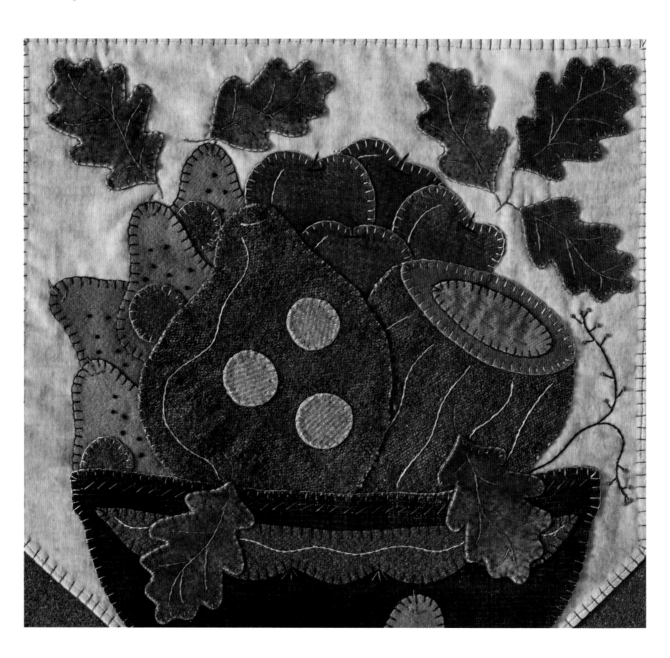

3. Using a steam iron on the wool setting, press the finished piece on the wrong side.

4. Turn all of the edges of the velvet under ¼″ and pin to the wool backing, centering it and leaving a border all the way around.

5. Using the blanket stitch, appliqué the finished velvet piece to the 18″ × 22″ wool backing.

6. Cut the wool backing 1½″ from each side of the finished velvet piece, following the shape of the banner.

7. Using a steam iron on the wool setting, press the finished piece on the wrong side.

8. Blanket stitch all the way around the outside edge of the wool backing to finish the piece.

9. Fold the ribbons in half and stitch a piece of ribbon to each end along the top of the wool backing. Then stitch one in the middle.

10. Tie the ribbons to a rod for hanging.

------------------ *Hint* ------------------

I tied the ribbons to a short branch, which makes an attractive and appropriate hanger.

--

WINTER'S RAMBLE

Finished table rug: 30″ × 17″

Here in the North, we can have an early snowfall in November or December—or none at all. Either way, we like to ramble through the woods and fields at this time of year, catching the rays of the sun as its stay is shortened. There is still plenty of wildlife to see, and the many shades of browns, from the dried flower stalks to the bark of trees, lend themselves to ideas for colors and textures for future projects.

One of my favorite times to be out in this season is when the moon is full; it makes the most amazing patterns on the ground through bare tree branches. There is something so compelling about the night sky in winter. It seems so much brighter and filled with so many stars.

Bundles of winter's beauty for trimming porches and doorways

Photo by Joseph Montion

Animals and pictorial scenes are favorite motifs that I incorporate into woolies. This table rug's depiction of a night's flight through a moonlit forest brings a bit of the winter landscape into the home. So cozy up to the fireplace or bundle yourself into a comfortable chair to watch the evening's pageant through a window.

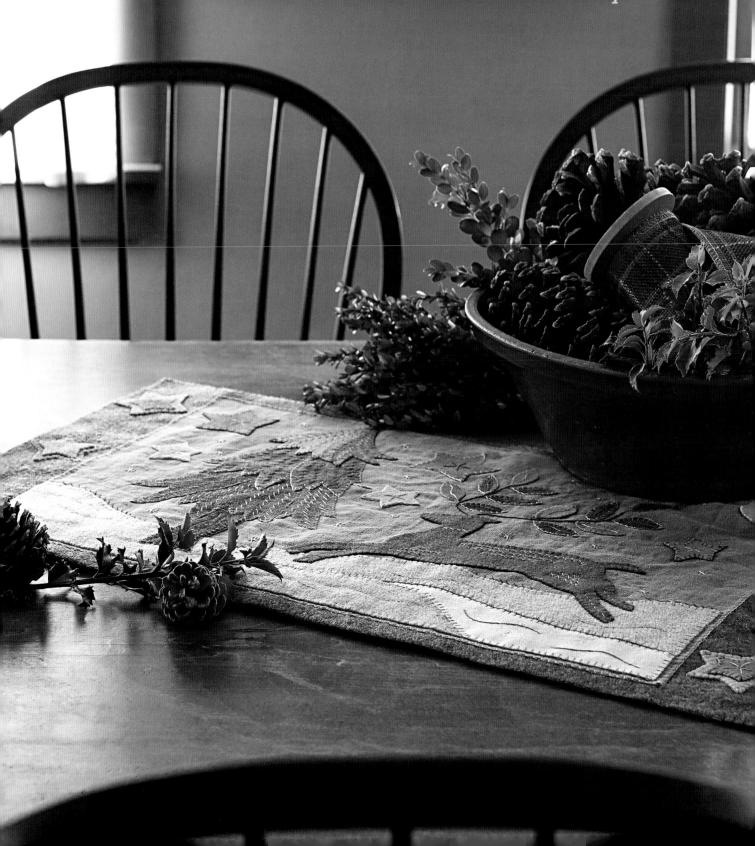

*Bring a bit of winter's
landscape inside.*

MATERIALS

Fabrics

- 1 green wool rectangle 30″ × 17″ for backing

- 1 taupe linen rectangle 23½″ × 15½″ for background

- 1 light tan wool rectangle 6″ × 10″ for moon and ground highlight

- 1 tan wool rectangle 7″ × 18″ for ground

- 1 dark brown wool rectangle 2″ × 6″ for tree trunk

- 1 medium brown wool rectangle 7″ × 12″ for deer

- 1 dark green wool rectangle 8″ × 9″ for tree branches and leaves

- 1 medium green wool square 6″ × 6″ for tree branches and leaves

- 1 light green wool square 6″ × 6″ for tree branches and leaves

- 1 mustard wool rectangle 6″ × 9″ for 3 big stars and 6 small stars

- 1 dark mustard wool rectangle 6″ × 10″ for 5 big stars and 3 small stars

Other materials

- Embroidery floss: 2 skeins each of dark brown, antique white, and mustard

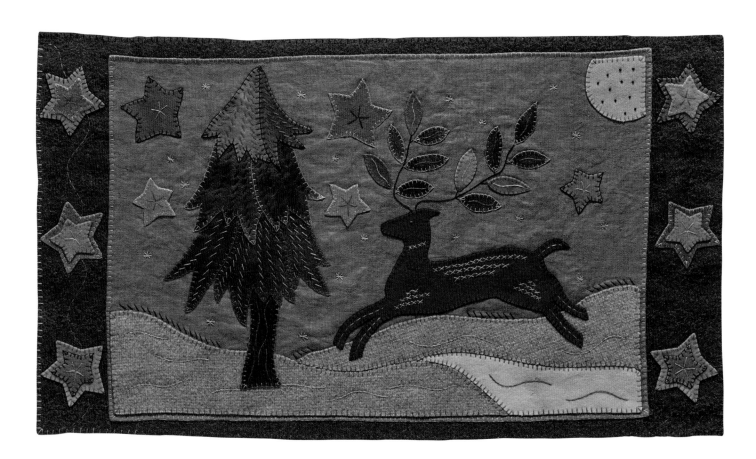

GETTING STARTED

Refer to Preparing the Wool Pieces (page 90) as needed for additional details on these steps.

1. Cut out the wool appliqué pieces using the pattern (pullout page P4).

2. Lay out the whole project to be sure you have all of the wool pieces.

SEWING FUN

Refer to Stitching Your Project (page 90) for details on the blanket stitch and embroidery stitches.

1. Using the blanket stitch, appliqué all of the wool pieces to the linen background, leaving ½″ along all of the edges for turning under later.

2. Add the embellishment stitches.

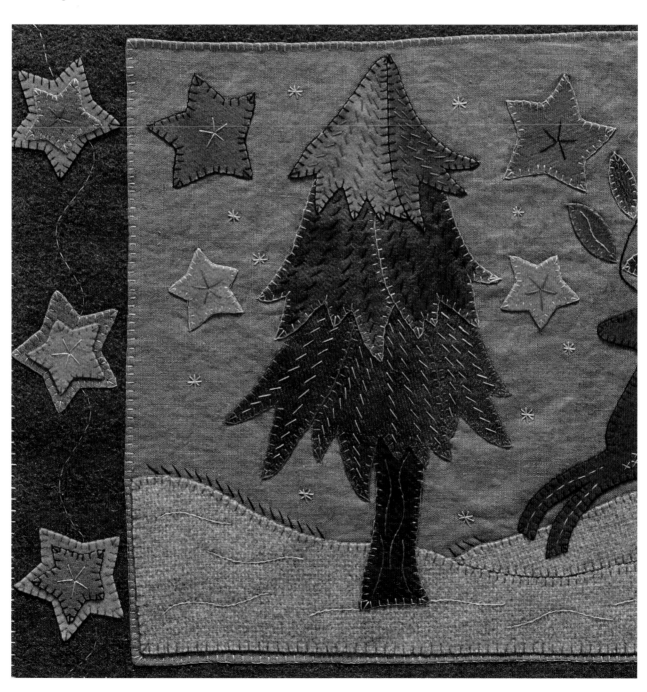

3. Using a steam iron on the wool setting, press the finished linen piece on the wrong side. Turn under the edges of the linen ¼″ all around and press.

4. Pin the linen in place on the wool backing, positioning it 1″ from the top and bottom edges and 3½″ from the sides. Using the blanket stitch, appliqué the linen to the wool.

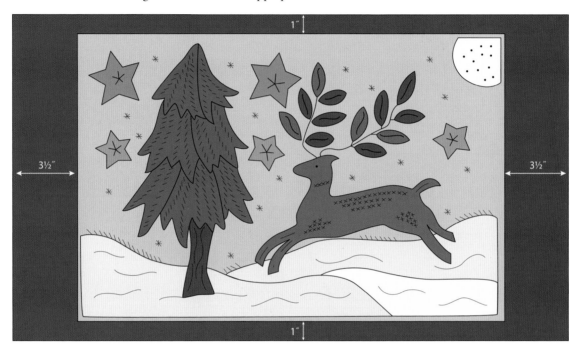

5. Blanket stitch the border stars into place.

6. Add the embellishment stitches.

7. Blanket stitch all the way around the outer edge of the wool backing.

8. Using a steam iron on the wool setting, press the finished piece on the wrong side.

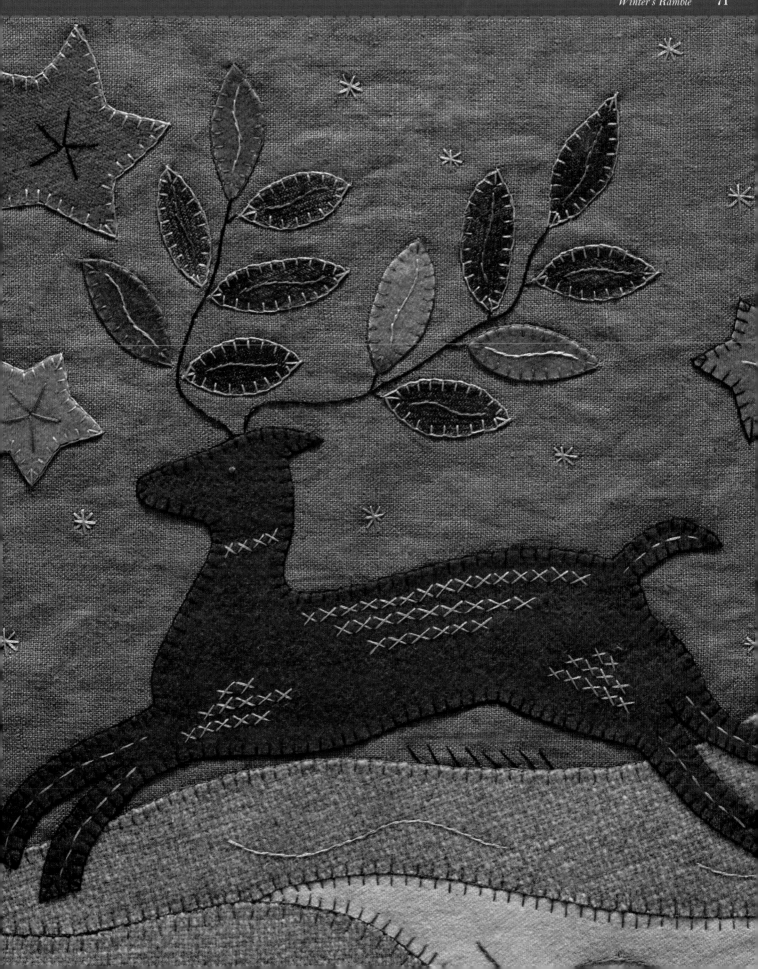

A HOUSE FOR TEA

Finished tea cozy: 10″ × 12″

*I*n our house, it's always time for tea. We like hot and cold tea, black tea, green tea, and chai tea. At all times of the year, someone is making tea of some kind. There is never a cup of tea too far from my reach as I work. We like to share our tea and often find a good reason to have someone over for a tea party. You know, things like Tuesdays, sunny days, and cloudy days—all are good reasons for tea parties. We are always on the hunt for new teas as well. If a shop is having a tea tasting, we will certainly join in. You never know where your next favorite flavor will come from.

On a brisk day, tea is a nice accompaniment to working on wool projects.

Photo by Joseph Montion

Having the right kind of tea cozy is essential for the serious tea drinker. It's also a nice addition to your home even if you are not a tea drinker but like the look of teapots and cups. Houses in general are a passion of mine, and I really feel that the shape of a cottage lends itself well to a tea cozy. This one has a great insulated liner to keep your tea nice and hot. So make one for yourself and for all of your tea-drinking friends to enjoy!

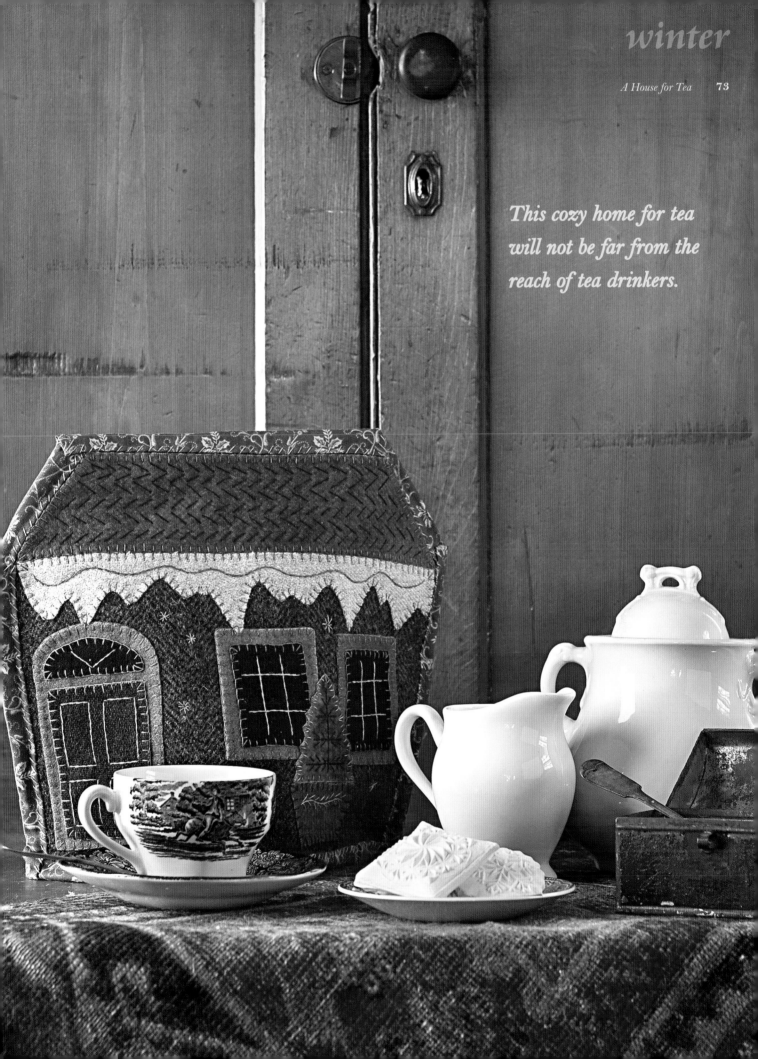

*This cozy home for tea
will not be far from the
reach of tea drinkers.*

MATERIALS

Fabrics

- 2 black-and-gray wool rectangles 10½″ × 12½″ for houses

- 1 dark orange wool rectangle 6″ × 13½″ for roofs and flower pots

- 1 medium blue wool rectangle 6″ × 13″ for door frames and window frames

- 1 dark blue wool rectangle 4″ × 6″ for door centers

- 1 black wool rectangle 5″ × 7″ for window centers and door arches

- 1 antique-white wool rectangle 2½″ × 12″ for icicles

- 1 green wool square 3″ × 6″ for leaves and shrub

- 1 medium orange wool rectangle 2″ × 3″ for tulips

- 2 cotton print strips 1″ × 8″ for side binding

- 2 cotton print strips 1″ × 12″ for bottom binding

- 2 cotton print strips 1″ × 5″ for angled roof binding

- 1 cotton print strip 1″ × 10″ for top binding

- 2 flannel or cotton rectangles 10½″ × 12½″ for lining

Other materials

- Embroidery floss: 1 skein each of dark brown, antique white, and mustard

- 2 rectangles 10″ × 12″ of Insul-Fleece insulated interfacing (by C&T Publishing)

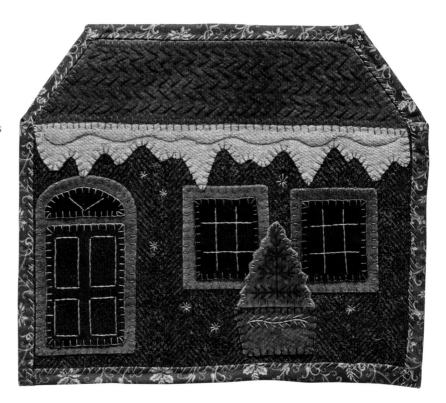

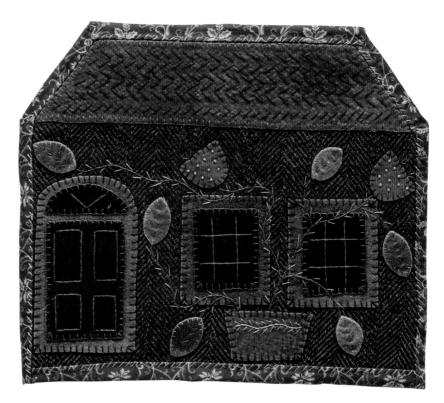

GETTING STARTED

Refer to Preparing the Wool Pieces (page 90) as needed for additional details on these steps.

1. Cut out the wool appliqué pieces and backgrounds using the patterns (pullout pages P1 and P4).

2. Lay out the whole project to be sure you have all of the wool pieces. You should have pieces for both sides of the tea cozy—one with icicles and a winter shrub and one with flowers and leaves.

3. Using a steam iron on the polyester setting, press the freezer-paper pattern for the house to the Insul-Fleece, and cut a house from each rectangle.

4. Cut out 2 flannel or cotton lining pieces using the freezer-paper pattern for the house.

SEWING FUN

Refer to Stitching Your Project (page 90) for details on the blanket stitch and embroidery stitches.

1. Using the blanket stitch, appliqué all of the wool pieces to the 2 wool background pieces.

2. Add the embellishment stitches.

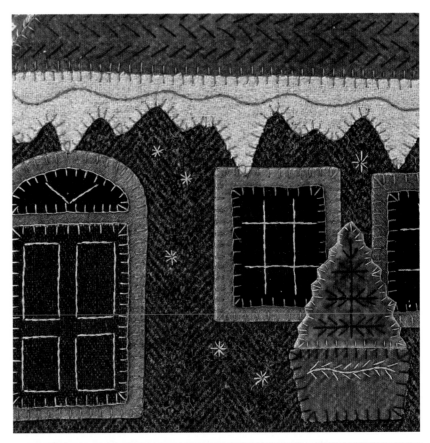

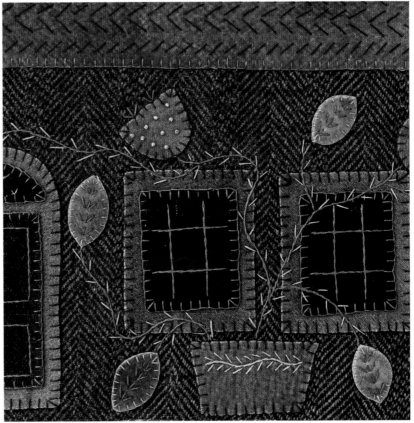

3. Using a steam iron on the wool setting, press the 2 finished pieces on the wrong sides.

4. Layer and pin together a finished house piece, the Insul-Fleece, and the flannel or cotton lining. The wrong sides of the lining and wool house piece should face the Insul-Fleece. Repeat for the second side.

5. Fold the long edges of each of the binding strips over to the wrong side ¼″ and press. Fold in half with wrong sides together and press.

6. Open the 12″ binding strips and pin to the bottom of each house. Whipstitch into place on both the front and back sides.

7. Pin both of the layered pieces together and sew together around the sides and top, using a running stitch and ¼″ seam allowance.

note If the layers aren't too thick, you can sew all of them together by machine, using a walking foot to keep the layers from shifting.

8. Open the 5″ binding strips, pin to the angled sides of the roof, trim as needed, and whipstitch into place on both the front and back sides.

9. In the same manner, pin the 8″ binding pieces to each side of the house, turning under ¼″ at the ends and trimming the length if necessary. Whipstitch the binding into place on both the front and back sides.

10. Repeat Step 9 to add the 10″ binding strip to the top of the house.

It's teatime!

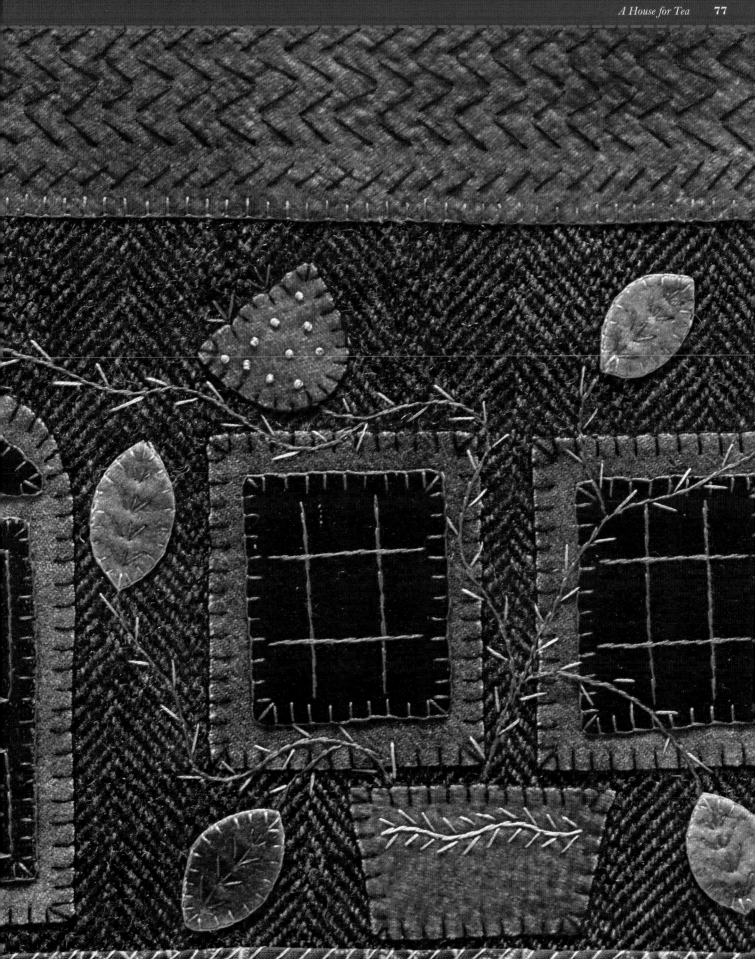

HER HEARTS

Finished table runner: 16″ × 36″

We have now come to the final project in this book of seasons. As winter comes to an end and we think of all that we have accomplished while we stayed warm and sheltered in our homes, there is always time for one last project before we begin our spring cleaning and garden preparations.

The heart is my favorite geometric motif—one that I use without sparing in many of my projects. It has a versatility that I find is a precious addition to my work. There is also a secret in this

A collection of the heart

Photo by Karly A. Smith

project from the heart. The secret is this: Between each large and small heart is stitched the name of someone very dear to me. It is a hidden acknowledgment, but as sincere as if I wrote it across the sky. As I stitched together each heart, enfolding in them the care of each name, I prayed for them, remembered special moments, and rejoiced that they have been a part of my life.

And to those who have read this book and perhaps stitched a project or two, I appreciate your taking the time to journey through the seasons with me.

*A heartfelt addition
to any room*

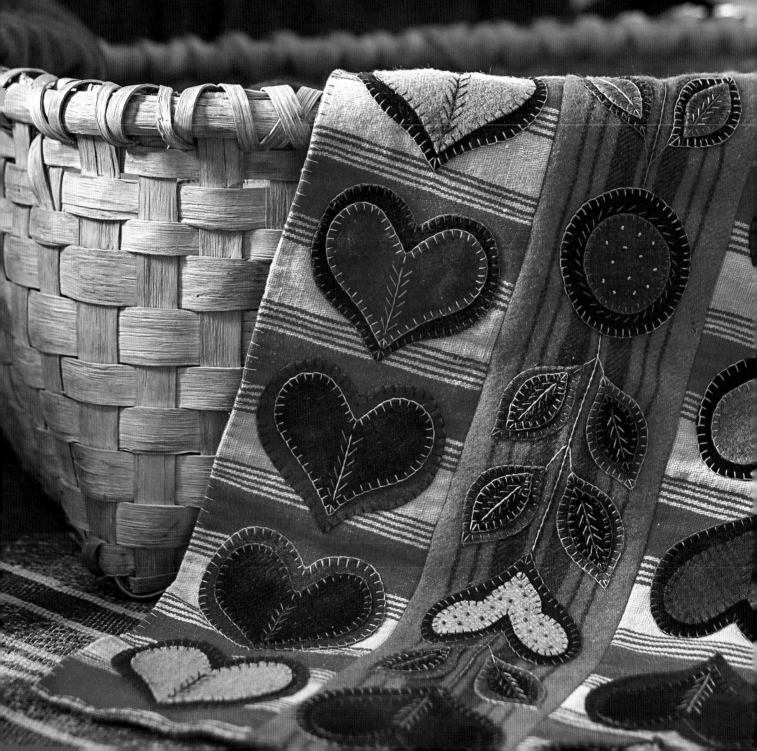

MATERIALS

Fabrics

- 1 red wool strip 5½″ × 36½″ for background

- 2 coordinating red linen or cotton strips 6″ × 36½″ for background

- 1 wool rectangle 16″ × 36″ for backing

- 8 assorted black wool squares 5″ × 5″ for large hearts

- 9 assorted red wool squares 5″ × 5″ for large hearts

- 1 antique-white wool square 5″ × 5″ for large heart

- 8 assorted black wool squares 4″ × 4″ for medium hearts

- 6 assorted red wool squares 4″ × 4″ for medium hearts

- 6 assorted antique-white wool squares 4″ × 4″ for medium hearts

- 1 antique-white wool rectangle 3″ × 7″ for 2 small hearts

- 1 dark green wool rectangle 5″ × 11″ for 6 large and 6 small leaves

- 1 light green wool rectangle 5″ × 11″ for 6 large and 6 small leaves

- 1 black wool square 4″ × 4″ for large circle

- 1 red wool square 3″ × 3″ for small circle

Other materials

- Embroidery floss: 3 skeins each of dark brown, antique white, and mustard

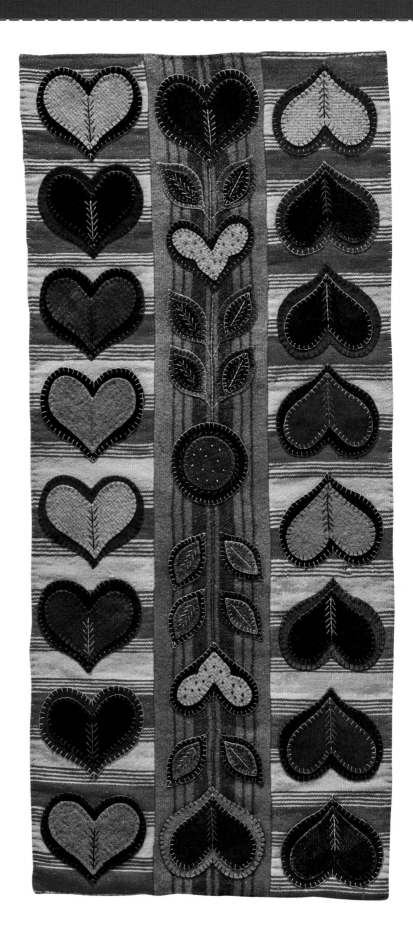

GETTING STARTED

Refer to Preparing the Wool Pieces (page 90) as needed for additional details on these steps.

1. Cut out the wool appliqué pieces using the patterns (page 83).

2. Lay out the whole project to be sure you have all of the wool pieces.

SEWING FUN

Refer to Stitching Your Project (page 90) for details on the blanket stitch and embroidery stitches.

1. Pin a linen or cotton strip to each side of the wool strip, right sides together. Sew by machine, using a ¼″ seam allowance.

2. Using a steam iron on the wool setting, press the seams open.

3. Using the blanket stitch, appliqué all of the wool pieces to the background.

4. Add the embellishment stitches.

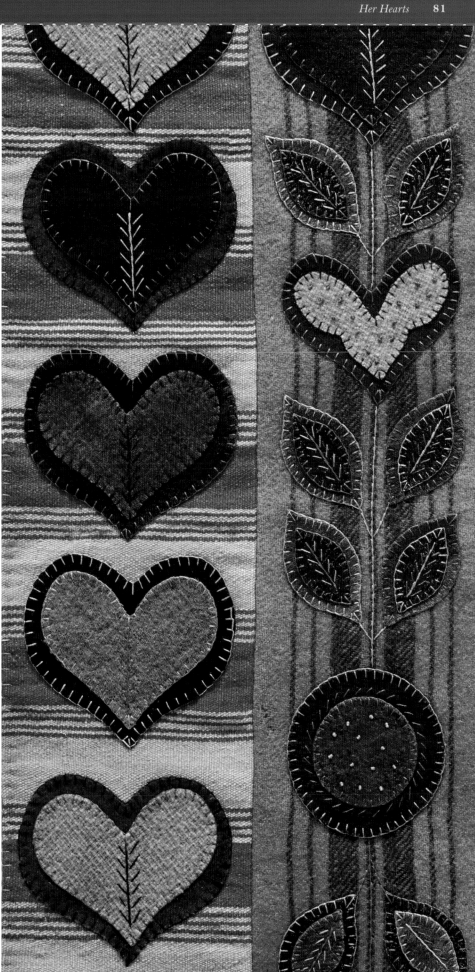

5. Turn the outer edges of the piece under ¼" all around and pin to the backing fabric.

6. Blanket stitch all the way around to finish the piece.

------------------ *Hint* ------------------

If you use wool for all three background strips, there is no need to turn under the edges. You will need to trim them to the size of the wool backing piece, however.

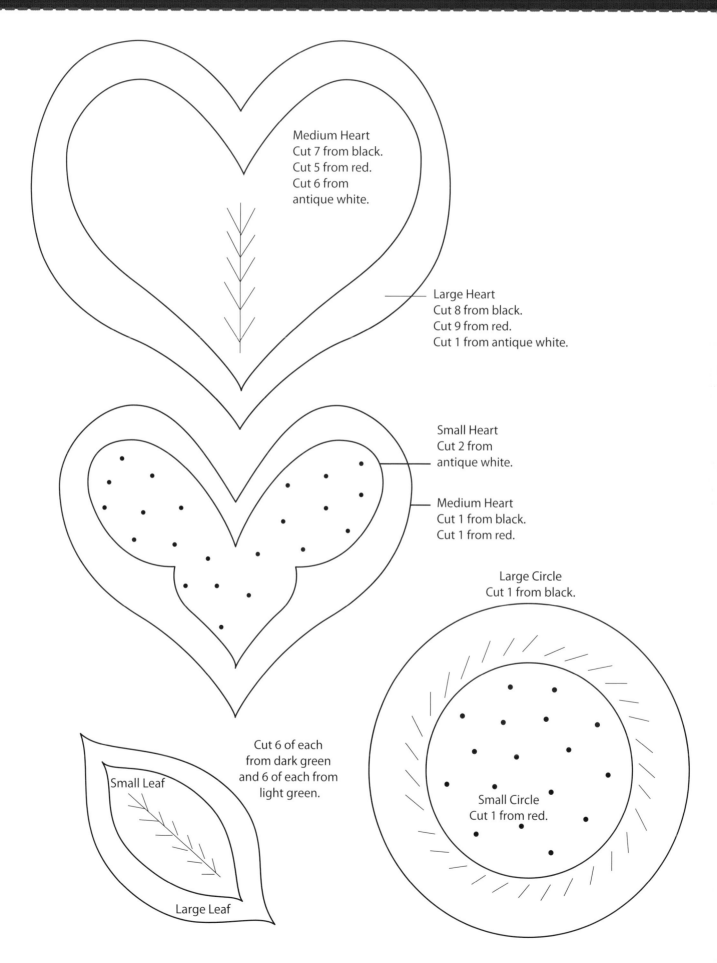

Medium Heart
Cut 7 from black.
Cut 5 from red.
Cut 6 from
antique white.

Large Heart
Cut 8 from black.
Cut 9 from red.
Cut 1 from antique white.

Small Heart
Cut 2 from
antique white.

Medium Heart
Cut 1 from black.
Cut 1 from red.

Large Circle
Cut 1 from black.

Small Circle
Cut 1 from red.

Cut 6 of each
from dark green
and 6 of each from
light green.

Small Leaf

Large Leaf

REMARKABLE WOOL

*I*n all of the years I have been working with wool, hardly a day goes by that I don't stitch, dye, cut, or buy wool. It's a wonderful textile medium to work with and offers much to the creative stitcher.

STORAGE AND USE

Given all of the projects that I work on, I had to come up with a creative way to keep the wools I am currently working with both handy and displayed in a pleasing way. I like to keep my studio in some kind of order so that I can design and create in a space without clutter. At the same time, I need to have a lot of wool handy for filling class kits, working up new designs, and cutting out pieces for a show. Having a place to stage your wool is a great way to keep you designing in a free yet organized way.

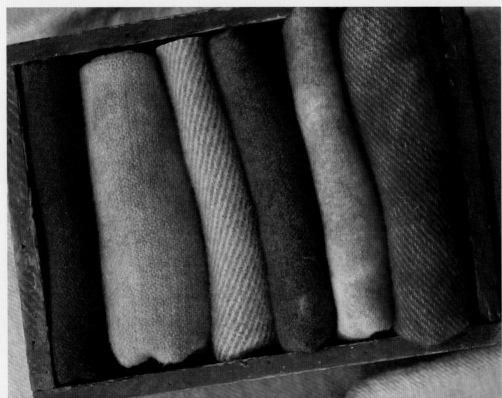

Photos by Rebekah L. Smith

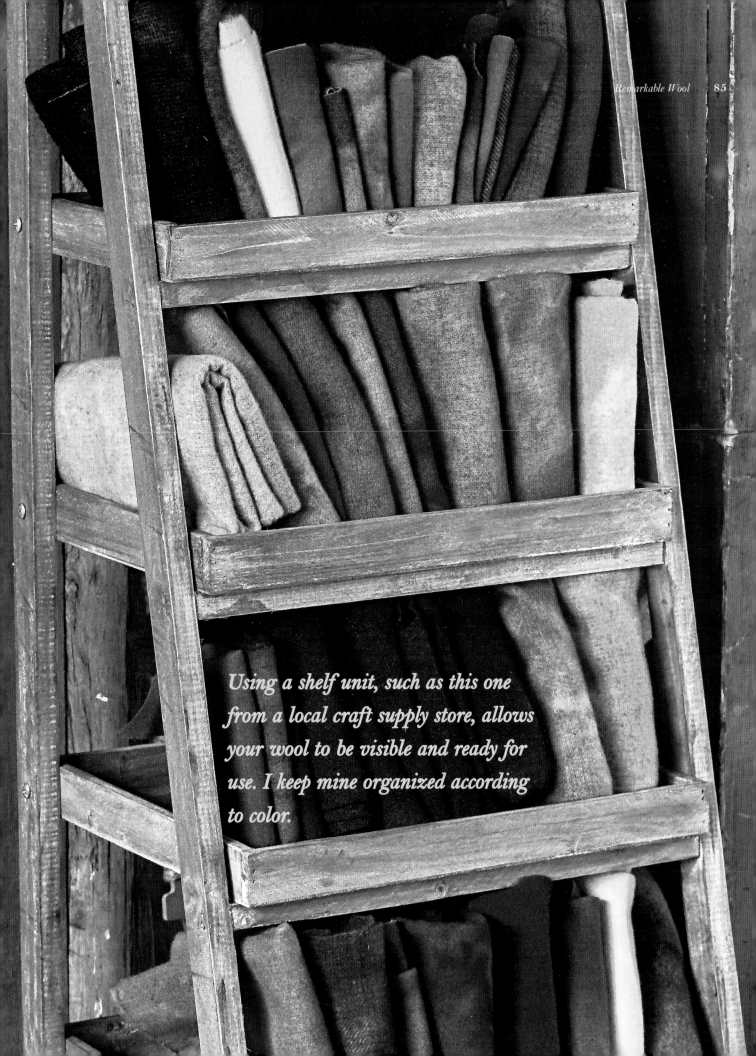

Using a shelf unit, such as this one from a local craft supply store, allows your wool to be visible and ready for use. I keep mine organized according to color.

Along with keeping wool separated in small plastic bins, I have also filled lots of baskets with wool, linen, velvet, and other fabrics. Baskets, both wire and woven, are a favorite storage look of mine. I use them for travel and displays as well. I can't get enough of these fabulous receptacles, which are not only practical but add a bit of style to your storage. Some of my baskets are old and some are new. In each basket, I keep some bits of lavender soap to discourage moths from feeling at home. The baskets are organized according to color or the specific project that the wool and other textiles are destined for.

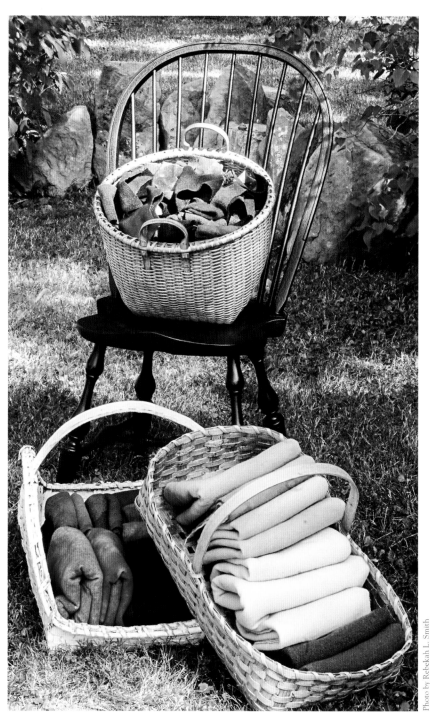

Baskets filled with wool are useful for storage, and they are also beautiful.

Photo by Rebekah L. Smith

COLLECTING

Putting together a wool collection is a delightful pastime. As time has gone by, my collection has grown to include new and old wools. New wool has become much easier to find because of the growing demand from different textile art industries. Over the years I have come across some wonderful retailers who specialize in a wide variety of fabulous wools. The other portion of my wool collection is made up of antique and vintage wool. These older items require some careful attention. Old fabrics have sometimes been stored in places where they might have been exposed to moths, for instance. I always carefully check each piece of fabric for any signs of these little pests. If I feel the piece is pest free, I then decide if it needs to be cleaned.

Before I put any piece of fabric in the washing machine, it gets the smell test. If I have any suspicions that it may have been stored with mothballs, I definitely keep it out of my washing machine and dryer, because the mothball smell can linger inside both machines for a while. I don't know what it is about mothballs, but the smell seems to be reactivated by water.

------------------------------ *Hint* ------------------------------

I have tried any number of remedies to get the mothball smell out of my old textiles. The best treatment that I have found so far is to hang the fabric on the line in very cold, dry weather. This also works well with musty smells. It takes a week or so of this to really clear up the mothball smell. If it is summertime, I will let the fabric hang on the line for several weeks, bringing it in whenever rain threatens.

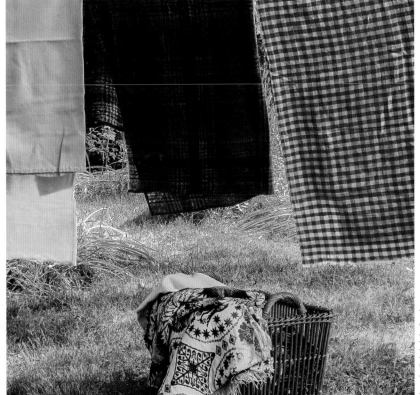

Photo by Rebekah L. Smith

Vintage textiles receive a good airing on the line.

Most of all, enjoy your wool and keep creating!

SNIPPING AND STITCHING

In this section, I'll cover the basic steps used to construct the projects in this book. Wool appliqué is really very easy and doesn't require a lot of tools or specific skills. Just select a project and gather the wool in the colors you have chosen (or vice versa), and you're ready to cut and stitch.

SUPPLIES FOR CUTTING AND STITCHING

You will need to gather some basic tools and supplies:

- Freezer paper
- Scissors for thread, fabric, and paper
- Fine-point felt-tip marker
- Iron
- Pins
- Embroidery needles
- Embroidery floss*

For the projects in this book, I used dark brown, dark mustard, and antique-white embroidery floss (DMC #3371, #829, #841). They coordinate well with my chosen color palette. Choose floss colors that best complement your own wool colors.

Basic tools you will need for the projects

PREPARING THE WOOL PIECES

1. Measure the wool for the background and cut it according to the dimensions given in the materials list for each project. In general, I add 1″ to the finished width and length measurements to allow for any shrinking that may occur during stitching. The background is trimmed to size later.

2. Trace the pattern pieces onto the dull side of the freezer paper and cut them out on the traced lines. (You may want to make multiples of the same shape, or you can use the same freezer-paper pattern several times.)

3. Place the freezer-paper pattern pieces onto the appropriate wool, shiny side down. Set your iron for wool, and iron the freezer-paper pattern pieces onto the wool. Space them close together for the best use of the fabric.

4. Cut around the freezer-paper pattern attached to the wool, making sure you have all the pieces needed for the project.

5. Keep the wool pieces organized in a plastic bag or multiple bags, and set them aside until you are ready to stitch.

6. Lay out all of the wool pieces on the background.

7. Pin only the bottom-most layer of wool pieces to the background first. I always stitch the bottom layer to the background first and then add the next layer or layers.

Iron the freezer-paper patterns securely to the wool.

Pin the wool shape to the background.

STITCHING YOUR PROJECT

There are a few basic stitches that are used in all of the projects in this book. Once you have learned these, they may be used in a variety of ways to adhere appliqués and embellish your project. I do all of my stitching with two strands of embroidery floss, but you may also use one strand of perle cotton #8. Cut the floss about 18″ long; longer lengths will tangle and fray as you stitch. I like to use one needle for each floss color as I'm working on a project.

Blanket Stitch

I use the blanket stitch to appliqué wool shapes to a background. Through my teaching, I have learned that each person has a natural rhythm to the stitching and an individual stitch length. I strive for consistent, even stitches, somewhere between ⅛″ and ¼″ long.

1. Knot the end of the floss and bring the needle and floss up through the background, right next to the piece you want to stitch.

2. Holding the piece you are stitching vertically, insert the needle down through the background 1 stitch length away along the edge of the appliqué. Bring the needle up through the 2 layers 1 stitch length in from the edge.

3. Pull the floss through until you have a small loop at the side.

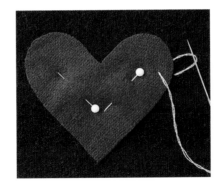

4. Insert the needle through the loop and draw the floss snug against the appliqué piece.

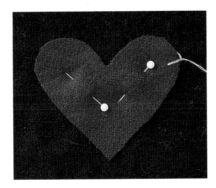

5. Repeat Steps 2–4 all the way around the piece. Repeat Step 1 as needed for any additional pieces and when you need to start a new length of thread.

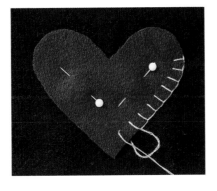

When you need to start a new length of floss, stop stitching at the outer edge after making a stitch into the appliqué. Insert the needle to the wrong side and knot off. Begin stitching inside the previous stitch by bringing the needle up through the background at the right angle. This will hide the stopping and starting points.

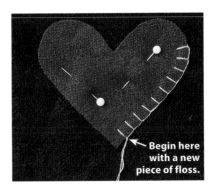

→ **Begin here with a new piece of floss.**

To make a crisp corner, insert the needle through the background at the point. Then bring the needle back up again next to where the needle went down to anchor the stitch at the point.

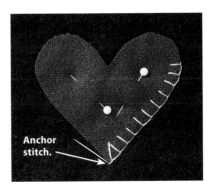

Anchor stitch.

Blanket Stitching the Outer Edges

The blanket stitch is also used to finish the raw edges of a wool piece.

1. Knot the floss and come up through the wrong side of the wool, 1 stitch length in from the raw edge. Trim the thread tail close to the knot.

2. Catch a bit of the fabric at the edge as shown, make a loop with the floss, and pull the needle through the loop.

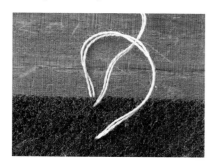

3. Insert the needle into the wool 1 stitch length away, and bring the needle up through the loop of thread. Draw it up snugly, but not too tight. Refer to Steps 4 and 5 of Blanket Stitch (page 91).

4. To make a crisp corner on the outside, make a tiny stitch at the point and take the needle through the loop to create a knot and anchor the next stitch.

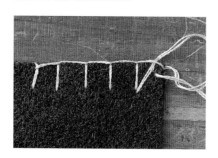

Embroidery Stitches

These stitches are used to add details and decorative elements to the appliqué pieces. I add embroidery stitching last, after the appliqués are stitched to the background. You can stitch them before if you prefer.

FRENCH KNOT

1. Knot the floss and bring the needle up through the wool where you want the French knot. Wrap the floss around the needle 5 times.

2. Push the wraps together and toward the point of the needle.

3. Insert the needle down through the wool, right next to where you came up. Holding on to the wraps with the thumb of your non-sewing hand, pull the needle through to the other side. This will create a round knot on the surface.

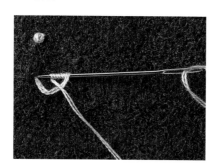

OUTLINE STITCH

1. Knot the floss and bring the needle up through the wool at point A. Insert the needle down at B and up at C, about halfway between A and B. Pull the thread through to make a stitch. Insert

the needle down again at D and up next to B for the second stitch.

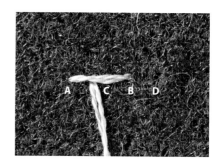

2. Repeat the stitch until you have stitched as far as you want. Keep the stitches even and keep the thread below the line of stitching.

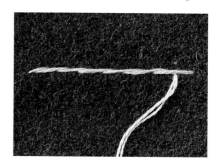

---------- *Hint* ----------

When I stitch text or other complex designs on light wool, I mark the wool using a fine-point felt-tip marker and stitch with a darker floss. On dark wool, I just wing it. If you want to mark a design on dark fabric, try using a chalk marking pencil in a light color.

RUNNING STITCH

1. Knot the floss and bring the needle up through the wool. Insert the needle back down to the wrong side and up again to make the stitch.

2. Insert the needle back down and continue to make a series of stitches in a row. Keep the stitch length even and consistent.

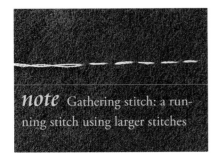

note Gathering stitch: a running stitch using larger stitches

WHIPSTITCH

1. Knot the floss and bring the needle up through the wool. Insert the needle back down to make an angled stitch.

2. Bring the needle up again and continue to make a series of stitches at an angle. These can be close together to close an opening or farther apart to create a design.

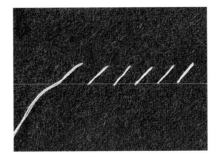

CROSS-STITCH

1. Knot the floss and bring the needle up through the wool. Insert the needle back down to make an angled stitch.

2. Bring the needle up again and continue to make a series of stitches at an angle.

3. Make diagonal stitches in the opposite direction to finish the crosses.

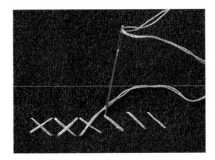

STARS

1. Knot the floss and bring the needle up through the wool where you want the center of the star. Insert the needle back down through the wool to make a stitch. This first stitch will determine the size of the star.

2. Repeat the stitch, coming up near the same center hole. Take a stitch in the opposite direction and then 2 stitches at a 90° angle to make a plus sign (+) or an X.

3. Take a stitch between each of the 4 stitches until you have made a total of 8 to create the star.

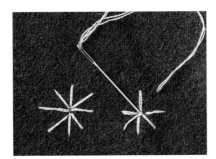

FINISHING YOUR PROJECT

You will need a few additional tools to trim and complete some projects after stitching the appliqués.

- Rotary cutter, mat, and ruler*

- Iron with a steam setting

If you don't have a rotary cutter and mat, painter's tape and scissors will work.

1. Set your iron on the wool and steam settings and lay the stitched piece wrong side up on an ironing board. Press the entire piece carefully.

> *note* Steam is important to really smooth out the piece.

2. Using a rotary cutter: On a cutting mat, measure and trim the piece to the final background dimensions. Make sure the design is centered before trimming.

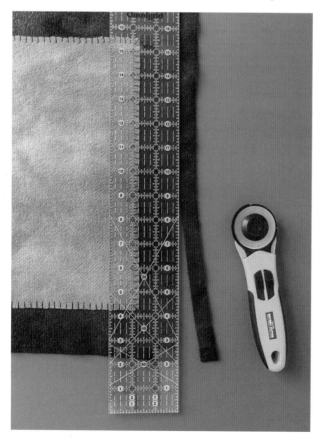

Using scissors: Measure each side to the final background dimensions. Use painter's tape to mark each side, making sure the design is centered. Trim the piece with scissors. Pull the tape off carefully, so as not to fray the edges of the wool.

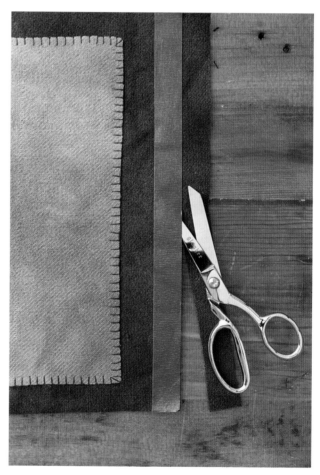

After trimming, finish the outer edges with a blanket stitch (see Blanket Stitching the Outer Edges, page 92), or use the method described in the project instructions.

RESOURCES

Natural-colored journal
consumercrafts.com

Small unfinished wooden stool
rebekahlsmith.com

Jute ribbon
amazon.com
michaels.com

Upholstery tape
hobbylobby.com

Grommet tool
amazon.com

Papier-mâché boxes
consumercrafts.com
hobbylobby.com
michaels.com

**DAP Weldwood nonflammable
contact cement (green can)**
amazon.com
lowes.com
walmart.com

Insul-Fleece
ctpub.com

Wool
attic-heirlooms.com
crowsontheledge.com
heavens-to-betsy.com
marcusfabrics.com

Needles (Chenille #24)
colonialneedle.com

**Freezer paper by the
8½″ × 11″ sheet**
ctpub.com

Floss
dmc-usa.com

ABOUT THE AUTHOR

Photo by Karly A. Smith.

Antiques have been a part of Rebekah Smith's life from an early age. She grew up surrounded by people who appreciated the simple lines and bold colors of early American folk art.

Rebekah graduated from the Art Institute of Pittsburgh with a degree in graphic design. It was Rebekah's mother who challenged her to paint on a cupboard in the style of early American muralist Rufus Porter, saying, "Try it and you can keep it." Rebekah has never stopped painting on old surfaces. She has studied Rufus Porter's style and Pennsylvania German folk art, both of which continually inspire her work. She also enjoys working on interiors, painting murals, and stenciling.

Rebekah's woolwork was inspired by a photo of an early American child's bedcover appliquéd with animals. Rebekah interpreted this piece into a reality for her youngest daughter. It was her first wool project and resulted in a new, textile-based inspiration. She now repurposes wool and hand dyes it, using a combination of natural and commercial dyes. Rebekah's passion lies in color and design, both talents that are well suited to folk art.

She and her husband, along with their three daughters, continually work to restore their 1838 house in the Western Reserve of Ohio.

Visit Rebekah's website at rebekahlsmith.com and her blog at rebekahlsmith.blogspot.com.

Want even more creative content?

Go to ctpub.com/offer

& sign up to receive our gift to you!

Make it, snap it, share it *using*